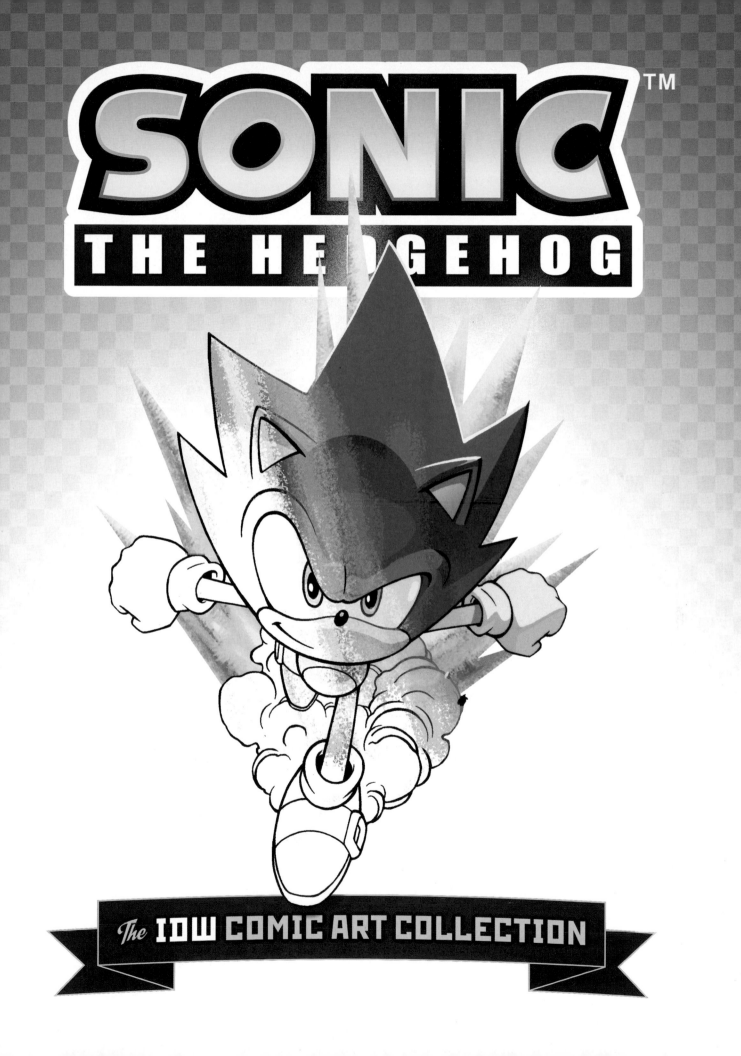

@IDWPUBLISHING
IDWPUBLISHING.COM

COVER ARTIST:
ADAM BRYCE THOMAS

COLLECTION EDITORS:
DAVID MARIOTTE
RILEY FARMER
ALONZO SIMON

COLLECTION GROUP EDITOR:
KRIS SIMON

COLLECTION DESIGNER:
SHAWN LEE

979-88-87240-42-8 26 25 24 23 1 2 3 4
979-88-88724-13-5 26 25 24 23 1 2 3 4

Davidi Jonas, CEO • Amber Huerta, COO • Mark Doyle, Co-Publisher • Tara McCrillis, Co-Publisher • Jamie S. Rich, Editor-In-Chief • Scott Dunbier, VP Special Projects • Sean Brice, Sr. Director Sales & Marketing • Lauren LePera, Sr. Managing Editor • Shauna Monteforte, Sr. Director of Manufacturing Operations • Jamie Miller, Director Publishing Operations • Greg Foreman, Director DTC Sales & Operations • Nathan Widick, Director of Design • Neil Uyetake, Sr. Art Director, Design & Production

Ted Adams and Robbie Robbins, IDW Founders

Special thanks to Mai Kiyotaki, Aña Khan, Michael Cisneros, Sandra Jo, Sonic Team, and everyone at Sega for their invaluable assistance.

For international rights, contact licensing@idwpublishing.com

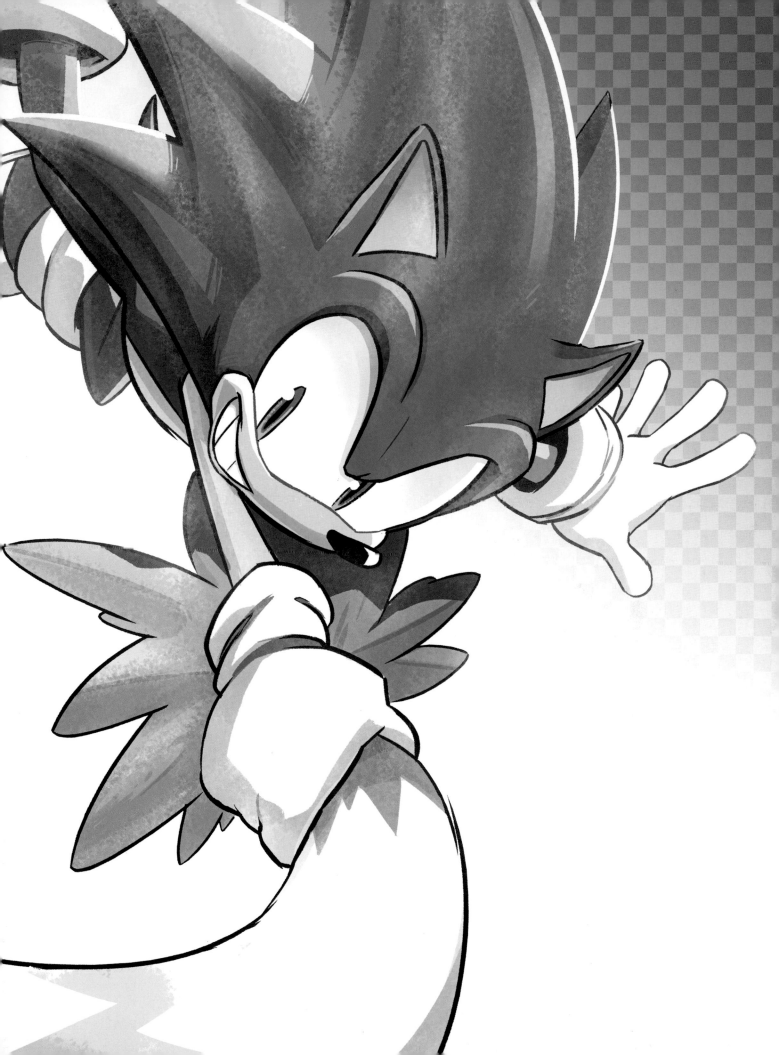

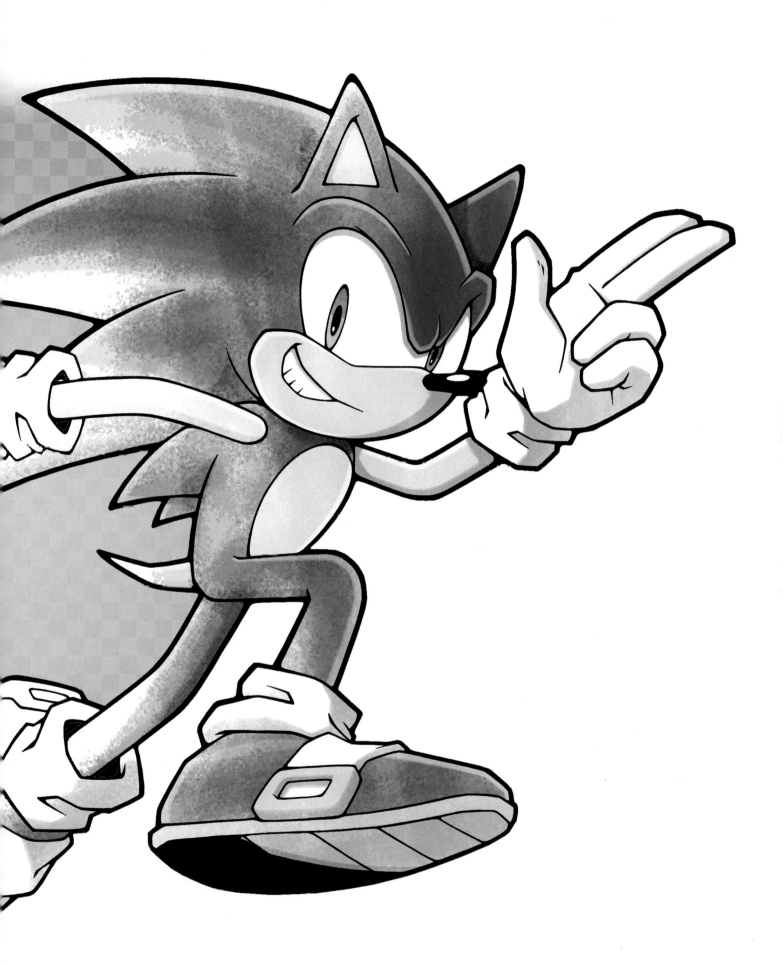

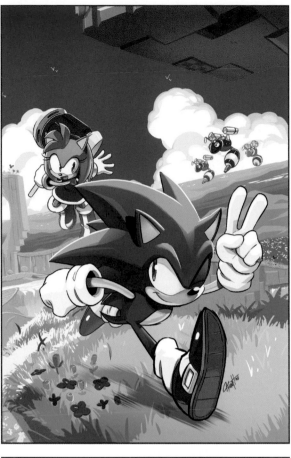

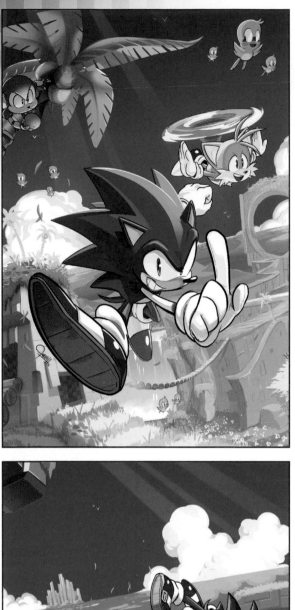

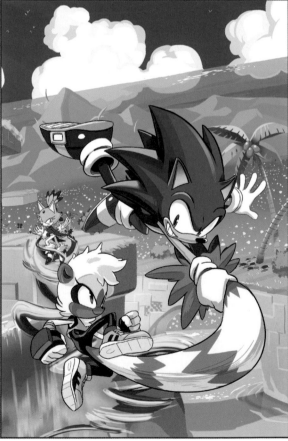

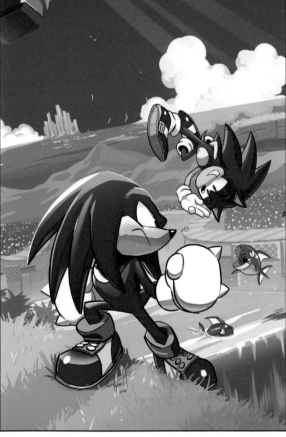

SONIC THE HEDGEHOG #1-4
COVER A CONNECTING
ART BY TYSON HESSE

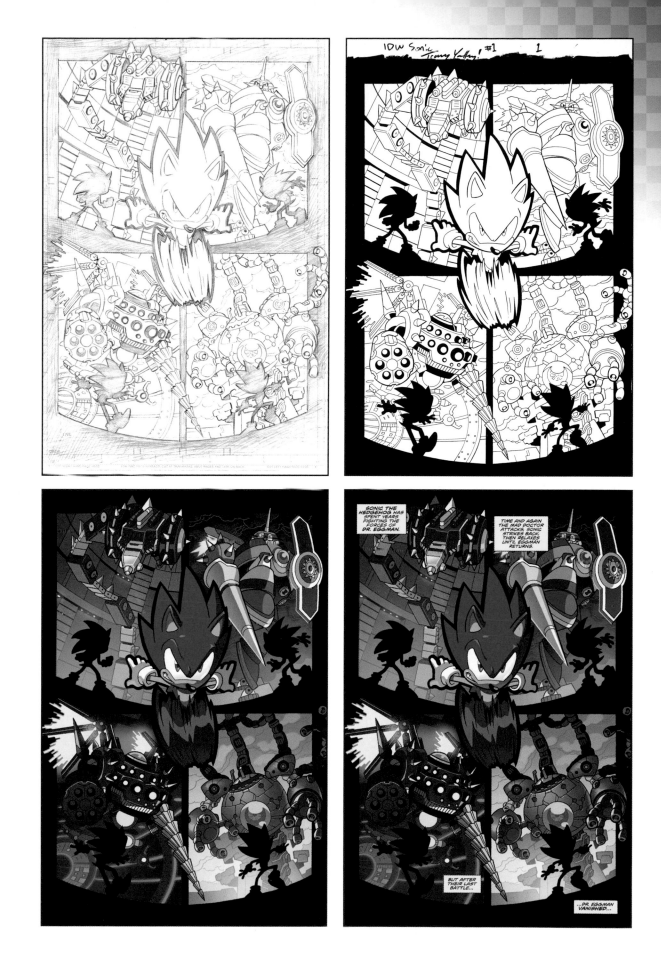

TOP LEFT
SONIC THE HEDGEHOG #1
PAGE 1
PENCILS BY **TRACY YARDLEY**

TOP RIGHT
SONIC THE HEDGEHOG #1
PAGE 1
INKS BY **JIM AMASH**

BOTTOM LEFT
SONIC THE HEDGEHOG #1
PAGE 1
COLORS BY **MATT HERMS**

BOTTOM RIGHT
SONIC THE HEDGEHOG #1
PAGE 1
LETTERS BY **COREY BREEN**

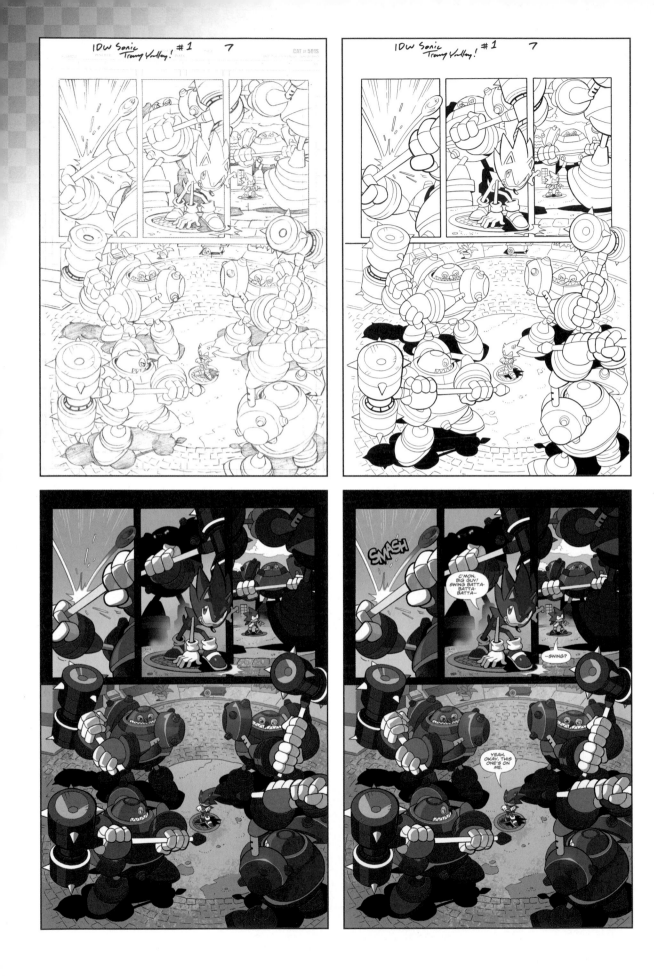

TOP LEFT
SONIC THE HEDGEHOG #1
PAGE 7
PENCILS BY **TRACY YARDLEY**

TOP RIGHT
SONIC THE HEDGEHOG #1
PAGE 7
INKS BY **JIM AMASH**

BOTTOM LEFT
SONIC THE HEDGEHOG #1
PAGE 7
COLORS BY **MATT HERMS**

BOTTOM RIGHT
SONIC THE HEDGEHOG #1
PAGE 7
LETTERS BY **COREY BREEN**

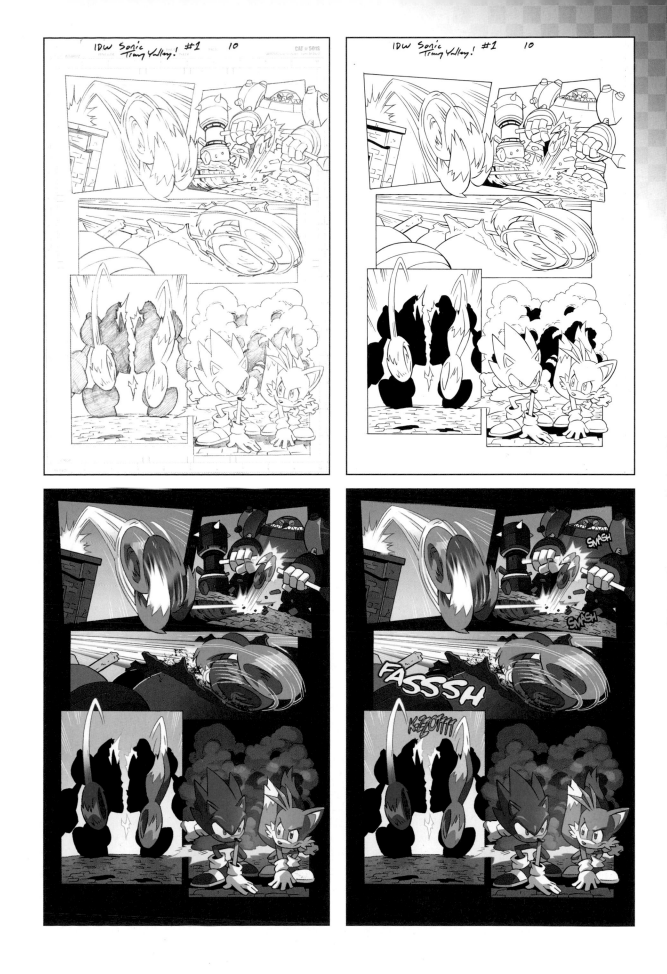

TOP LEFT
SONIC THE HEDGEHOG #1
PAGE 10
PENCILS BY **TRACY YARDLEY**

TOP RIGHT
SONIC THE HEDGEHOG #1
PAGE 10
INKS BY **BOB SMITH**

BOTTOM LEFT
SONIC THE HEDGEHOG #1
PAGE 10
COLORS BY **MATT HERMS**

BOTTOM RIGHT
SONIC THE HEDGEHOG #1
PAGE 10
LETTERS BY **COREY BREEN**

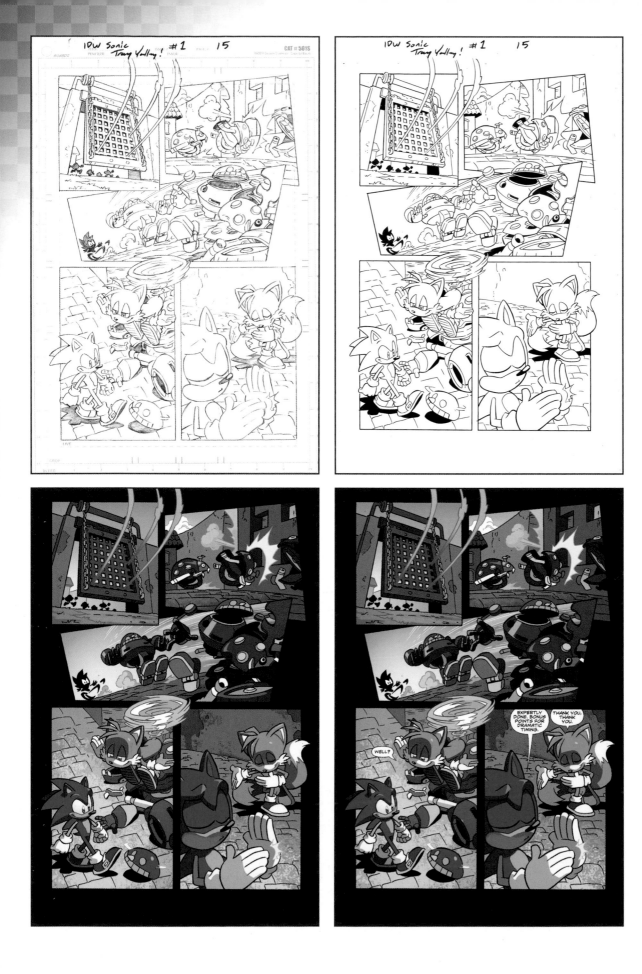

TOP LEFT
SONIC THE HEDGEHOG #1
PAGE 15
PENCILS BY **TRACY YARDLEY**

TOP RIGHT
SONIC THE HEDGEHOG #1
PAGE 15
INKS BY **BOB SMITH**

BOTTOM LEFT
SONIC THE HEDGEHOG #1
PAGE 15
COLORS BY **MATT HERMS**

BOTTOM RIGHT
SONIC THE HEDGEHOG #1
PAGE 15
LETTERS BY **COREY BREEN**

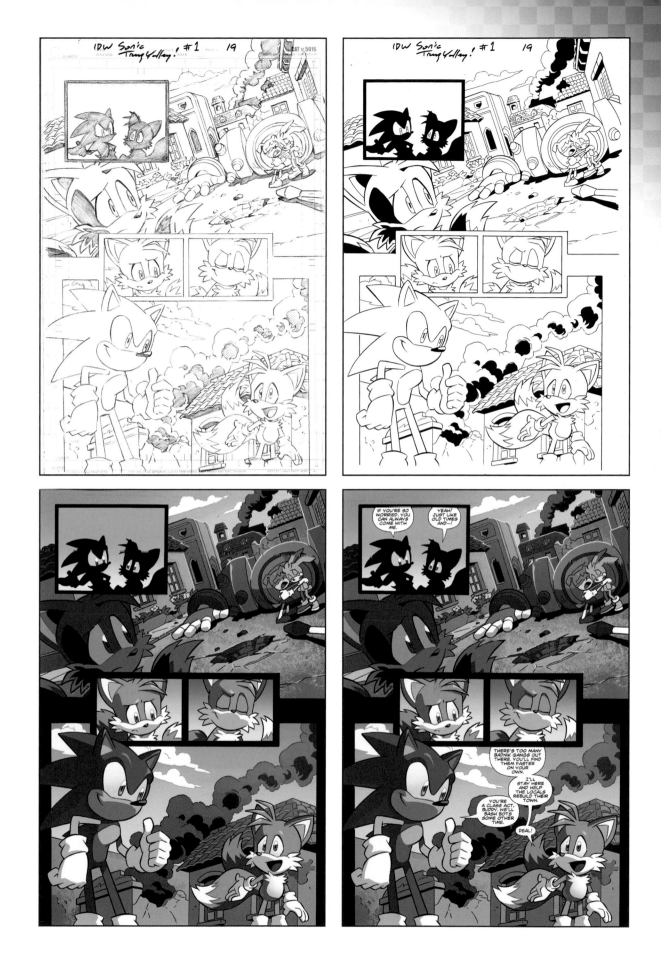

TOP LEFT
SONIC THE HEDGEHOG #1
PAGE 19
PENCILS BY **TRACY YARDLEY**

TOP RIGHT
SONIC THE HEDGEHOG #1
PAGE 19
INKS BY **BOB SMITH**

BOTTOM LEFT
SONIC THE HEDGEHOG #1
PAGE 19
COLORS BY **MATT HERMS**

BOTTOM RIGHT
SONIC THE HEDGEHOG #1
PAGE 19
LETTERS BY **COREY BREEN**

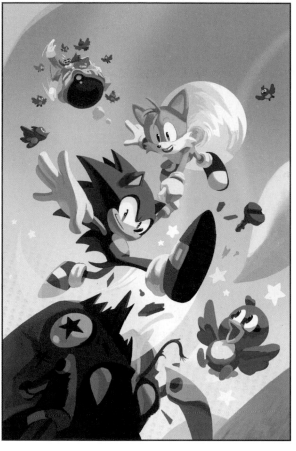

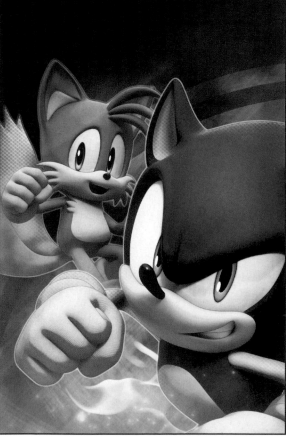

TOP LEFT
SONIC THE HEDGEHOG #1
COVER B
ART BY **TRACY YARDLEY**

TOP RIGHT
SONIC THE HEDGEHOG #1
INCENTIVE COVER
ART BY **NATHALIE FOURDRAINE**

BOTTOM LEFT
SONIC THE HEDGEHOG #1
INCENTIVE COVER
ART BY **RAFA KNIGHT**
SKETCH BY **AARON HAMMERSTROM**

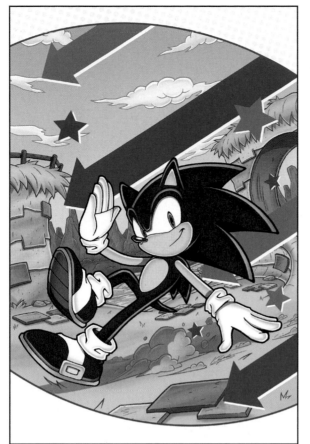

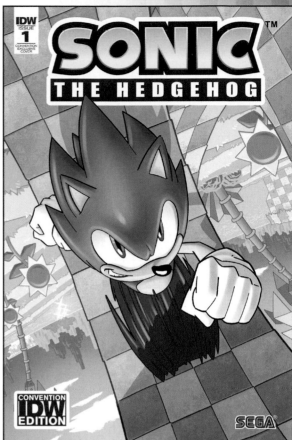

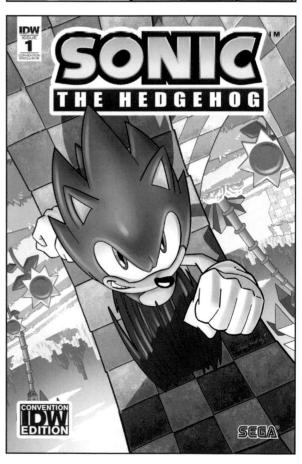

TOP LEFT
SONIC THE HEDGEHOG #1
INCENTIVE COVER
ART BY **KIERAN GATES**

TOP RIGHT
SONIC THE HEDGEHOG #1
EXCLUSIVE COVER
ART BY **TRACY YARDLEY**

BOTTOM RIGHT
SONIC THE HEDGEHOG #1
EXCLUSIVE COVER
ART BY **TRACY YARDLEY**

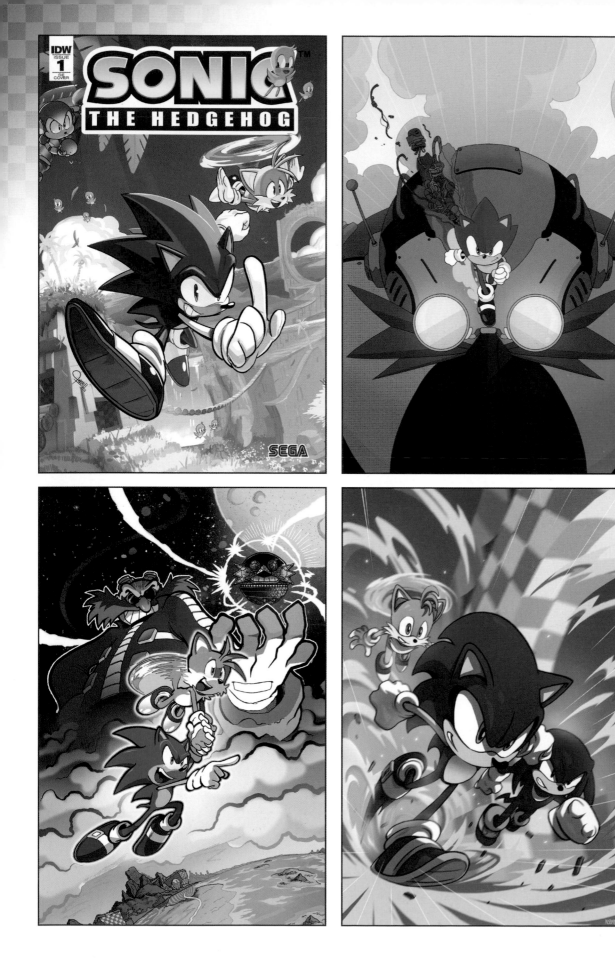

TOP LEFT
SONIC THE HEDGEHOG #1
EXCLUSIVE COVER
ART BY **TYSON HESSE**

TOP RIGHT
SONIC THE HEDGEHOG #1
EXCLUSIVE COVER
ART BY **DEVIN KRAFT**

BOTTOM LEFT
SONIC THE HEDGEHOG #1
EXCLUSIVE COVER
ART BY **JONATHAN GRAY**
COLORS BY **MATT HERMS**

BOTTOM RIGHT
SONIC THE HEDGEHOG #1
EXCLUSIVE COVER
ART BY **EDWIN HUANG**

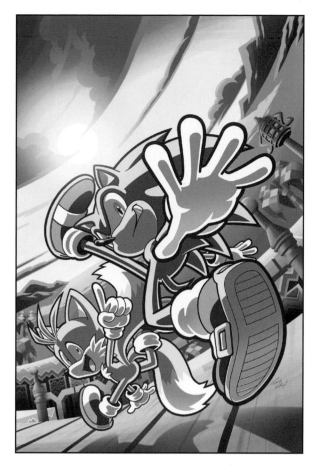

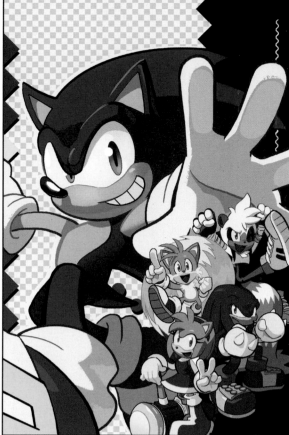

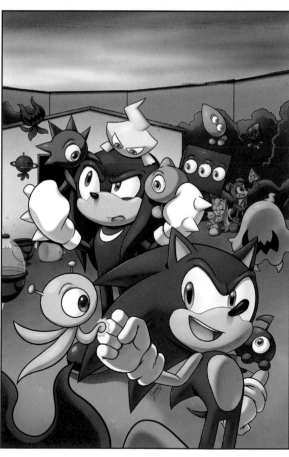

TOP LEFT
SONIC THE HEDGEHOG #1
5TH ANNIVERSARY EDITION
COVER B
ART BY TRACY YARDLEY

TOP RIGHT
SONIC THE HEDGEHOG #1
5TH ANNIVERSARY EDITION
COVER C
ART BY MATT HERMS

BOTTOM RIGHT
SONIC THE HEDGEHOG #1
5TH ANNIVERSARY EDITION
COVER D
ART BY JENNIFER HERNANDEZ

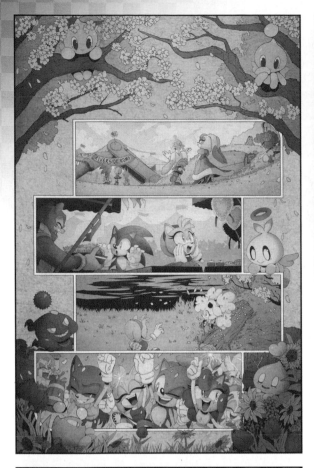

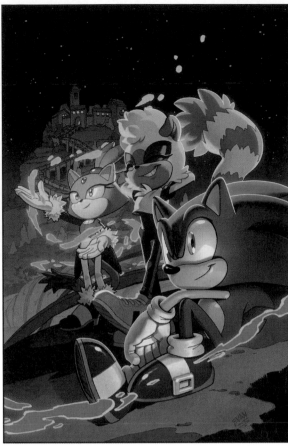

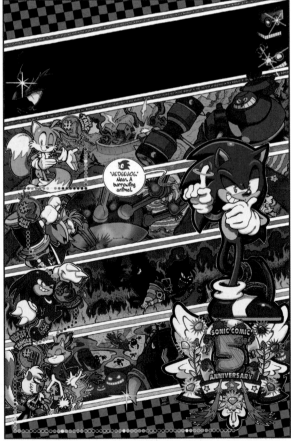

TOP LEFT
SONIC THE HEDGEHOG #1
5TH ANNIVERSARY EDITION
INCENTIVE COVER
ART BY **ADAM BRYCE THOMAS**
COLORS BY **REGGIE GRAHAM**

TOP RIGHT
SONIC THE HEDGEHOG #1
5TH ANNIVERSARY EDITION
INCENTIVE COVER
ART BY **EVAN STANLEY**

BOTTOM LEFT
SONIC THE HEDGEHOG #1
5TH ANNIVERSARY EDITION
INCENTIVE COVER
ART BY **JONATHAN GRAY**
COLORS BY **REGGIE GRAHAM**

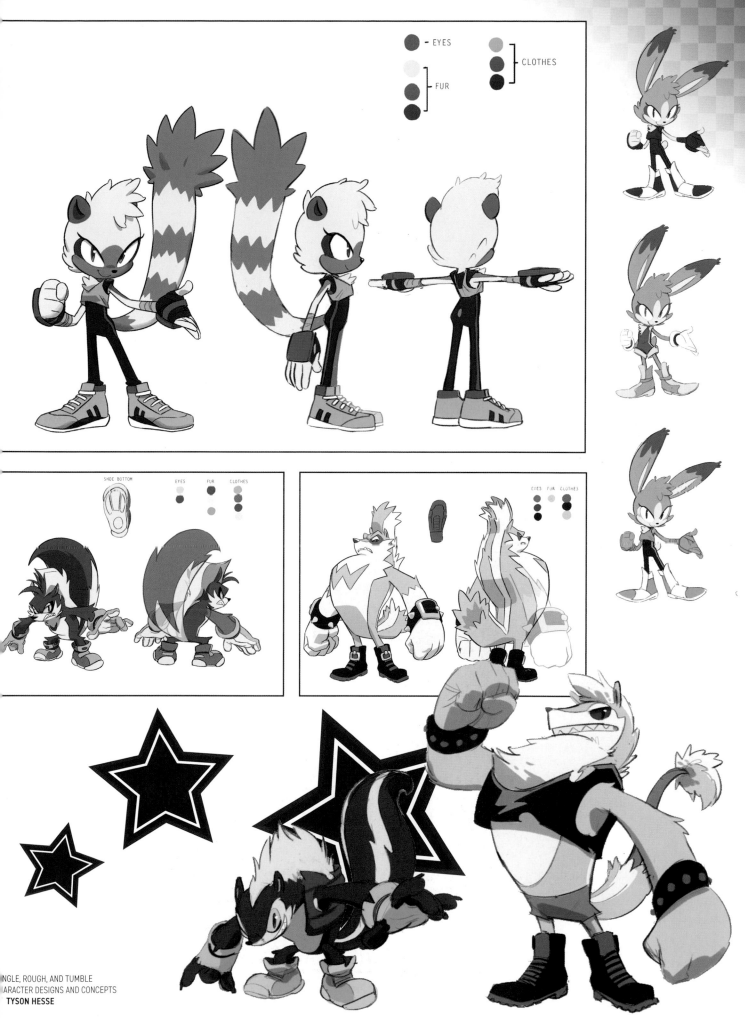

EYES

FUR

CLOTHES

SHOE BOTTOM EYES FUR CLOTHES

EYES FUR CLOTHES

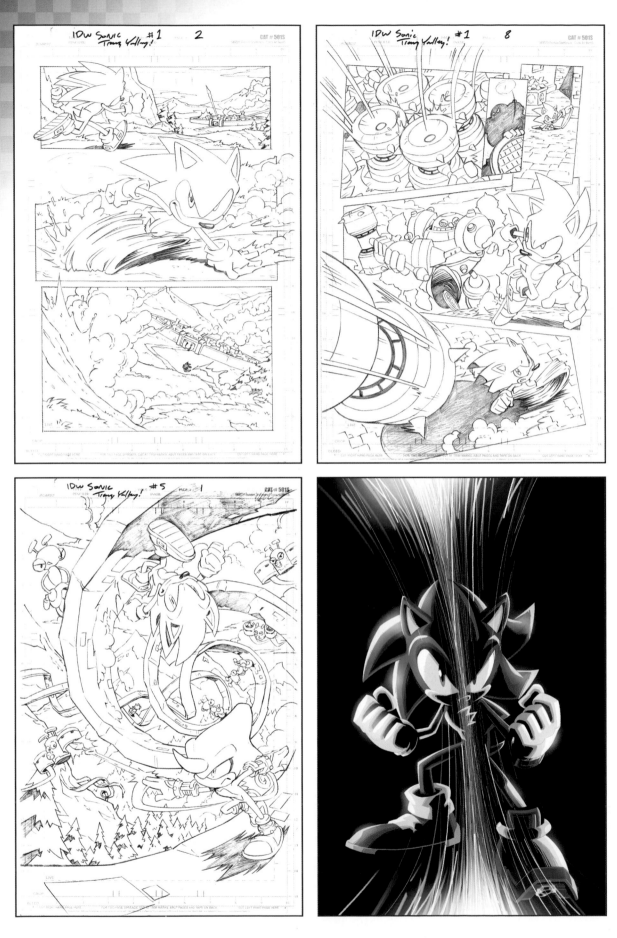

TRACY YARDLEY PENCILED THE FIRST ISSUE OF *SONIC THE HEDGEHOG* FOR IDW AND HAS CONTRIBUTED THROUGHOUT THE SERIES. ENJOY A SELECTION OF HIS AND OUR FAVORITE PIECES.

TOP LEFT
SONIC THE HEDGEHOG #1
PAGE 2
PENCILS

TOP RIGHT
SONIC THE HEDGEHOG #1
PAGE 8
PENCILS

BOTTOM LEFT
SONIC THE HEDGEHOG #5
PAGE 1
PENCILS

BOTTOM RIGHT
SONIC THE HEDGEHOG #6
COVER B

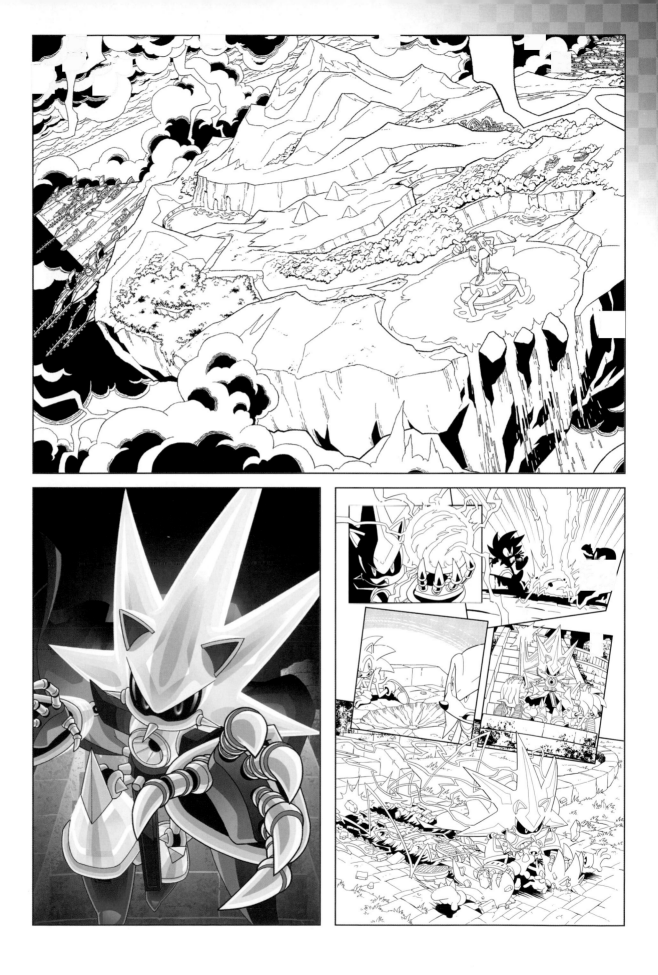

TOP
SONIC THE HEDGEHOG #9
PAGES 2-3
PENCILS & INKS

BOTTOM LEFT
SONIC THE HEDGEHOG #10
COVER B

BOTTOM RIGHT
SONIC THE HEDGEHOG #10
PAGE 2
PENCILS & INKS

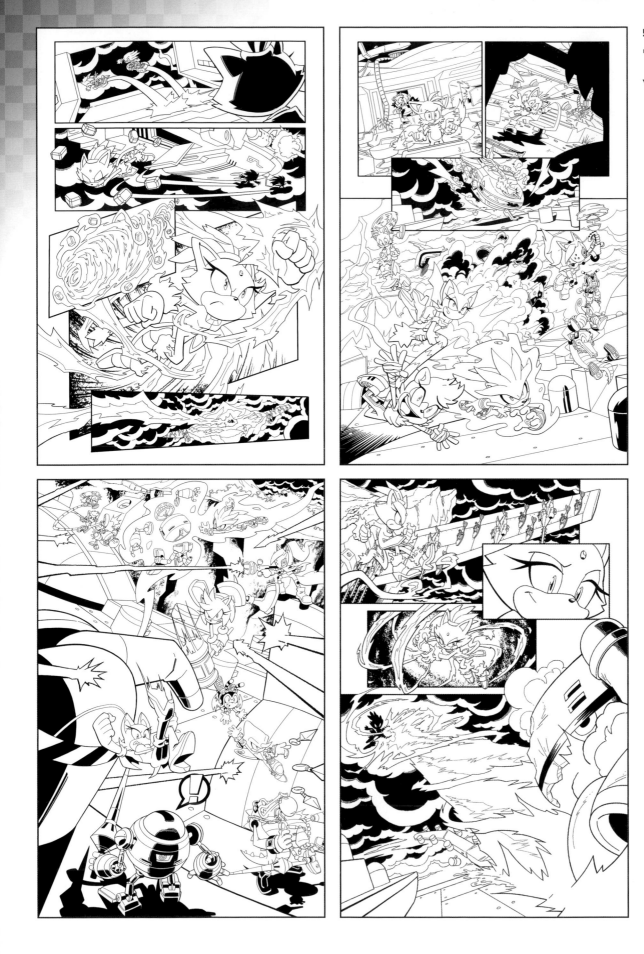

TOP LEFT
SONIC THE HEDGEHOG #9
PAGE 13
PENCILS & INKS

TOP RIGHT
SONIC THE HEDGEHOG #9
PAGE 14
PENCILS & INKS

BOTTOM LEFT
SONIC THE HEDGEHOG #9
PAGE 16
PENCILS & INKS

BOTTOM RIGHT
SONIC THE HEDGEHOG #9
PAGE 17
PENCILS & INKS

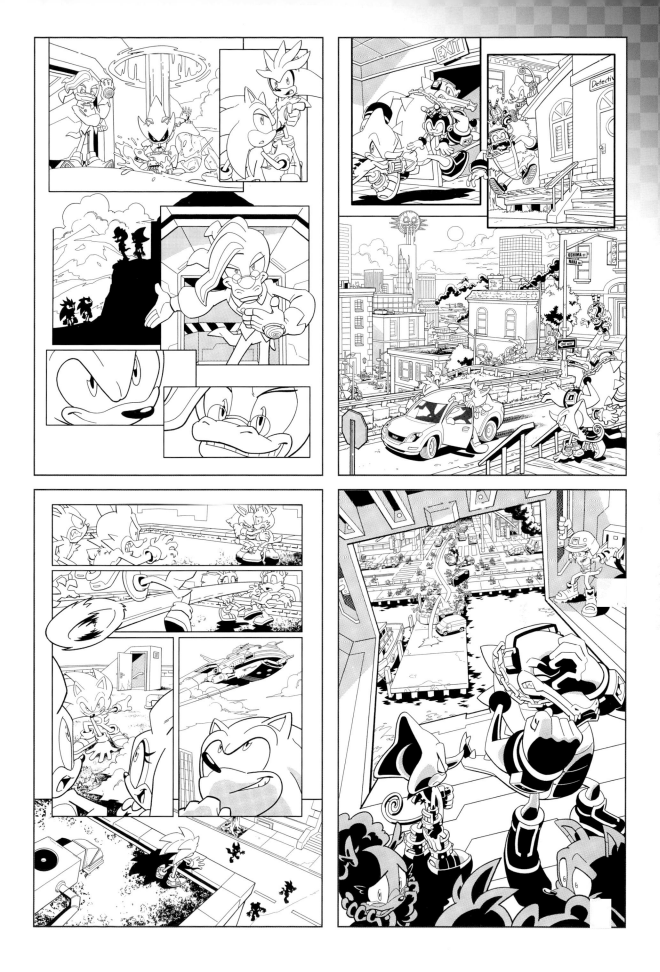

TOP LEFT
SONIC THE HEDGEHOG #14
PAGE 5
PENCILS & INKS

TOP RIGHT
SONIC THE HEDGEHOG #17
PAGE 3
PENCILS & INKS

BOTTOM LEFT
SONIC THE HEDGEHOG #17
PAGE 13
PENCILS & INKS

BOTTOM RIGHT
SONIC THE HEDGEHOG #17
PAGE 20
PENCILS & INKS

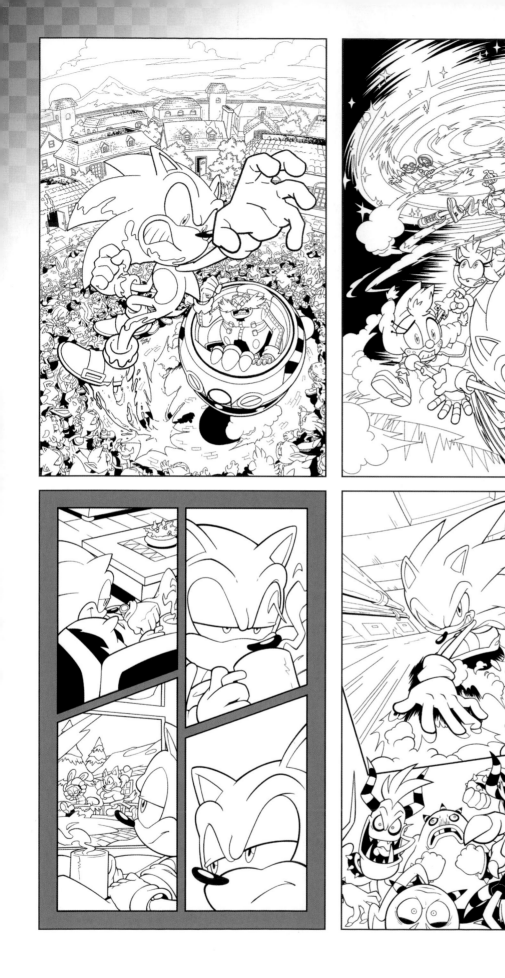

TOP LEFT
SONIC THE HEDGEHOG #23
COVER B
PENCILS & INKS

TOP RIGHT
SONIC THE HEDGEHOG #40
COVER A
PENCILS & INKS

BOTTOM LEFT
SONIC THE HEDGEHOG #42
PAGE 4
PENCILS & INKS

BOTTOM RIGHT
SONIC THE HEDGEHOG #42
PAGE 20
PENCILS & INKS

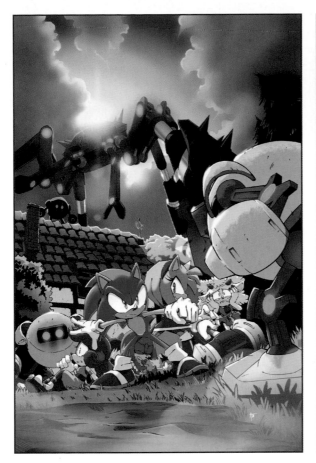

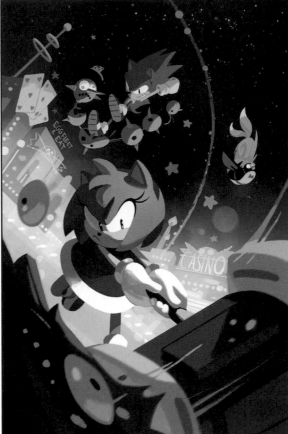

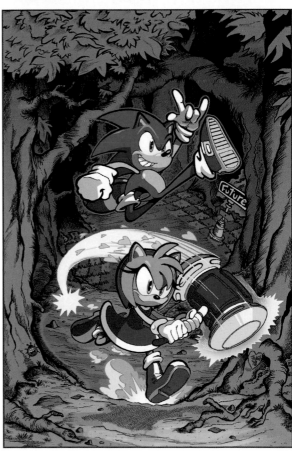

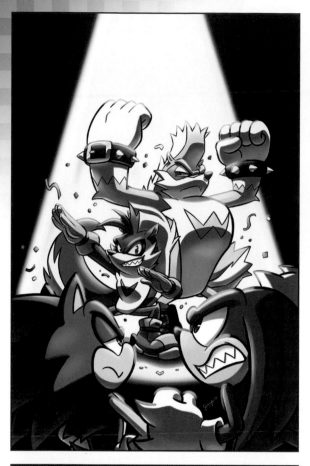

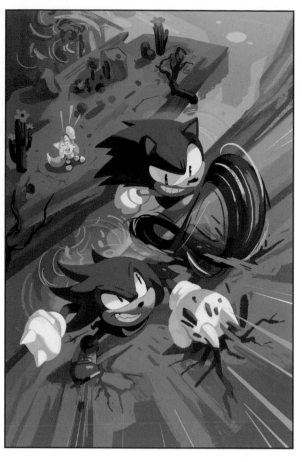

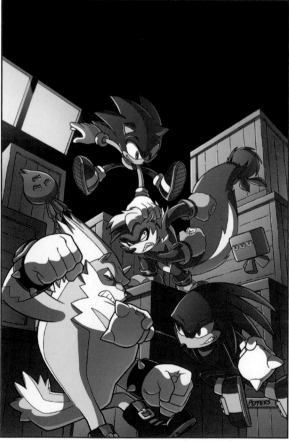

TOP LEFT
SONIC THE HEDGEHOG #3
COVER B
ART BY **JENNIFER HERNANDEZ**

TOP RIGHT
SONIC THE HEDGEHOG #3
INCENTIVE COVER
ART BY **NATHALIE FOURDRAINE**

BOTTOM LEFT
SONIC THE HEDGEHOG #3
INCENTIVE COVER
ART BY **JAMAL PEPPERS**
COLORS BY **HEATHER BRECKEL**

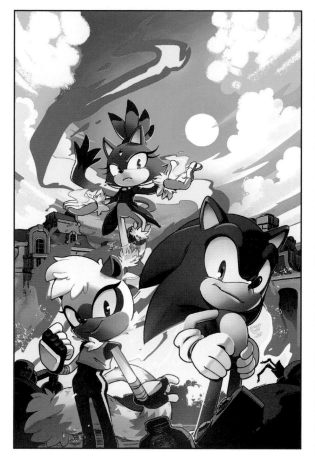

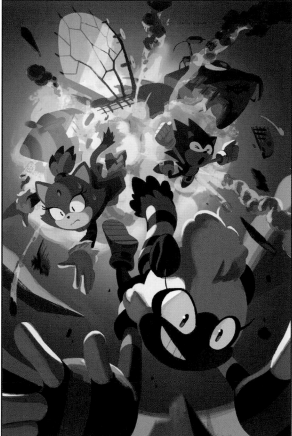

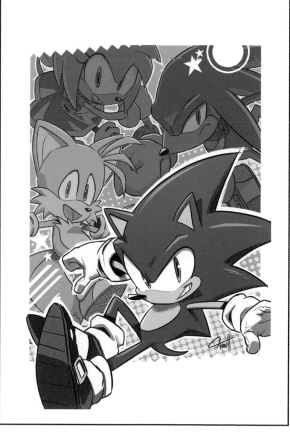

TOP LEFT
SONIC THE HEDGEHOG #4
COVER B
ART BY EVAN STANLEY
COLORS BY MATT HERMS

TOP RIGHT
SONIC THE HEDGEHOG #4
INCENTIVE COVER
ART BY NATHALIE FOURDRAINE

BOTTOM RIGHT
SONIC THE HEDGEHOG #4
INCENTIVE COVER
ART BY TYSON HESSE

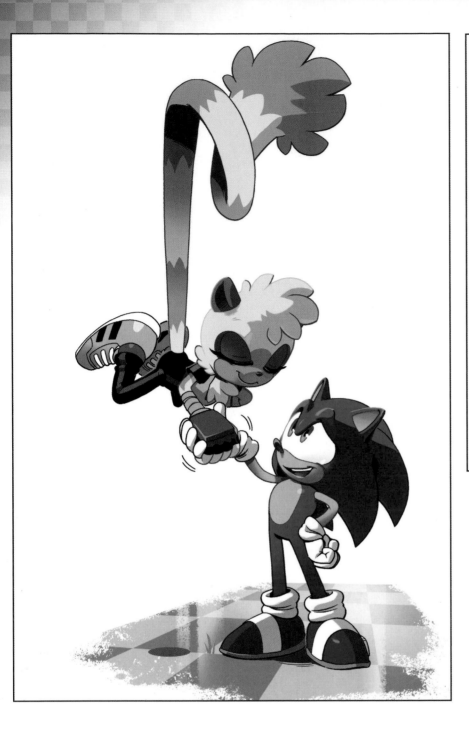

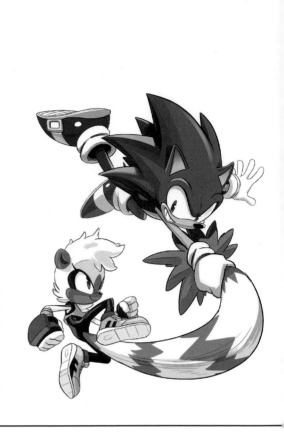

LEFT
SONIC THE HEDGEHOG #4
SECOND PRINTING COVER
ART BY **EVAN STANLEY**

RIGHT
SONIC THE HEDGEHOG #4
EXCLUSIVE COVER
ART BY **TYSON HESSE**

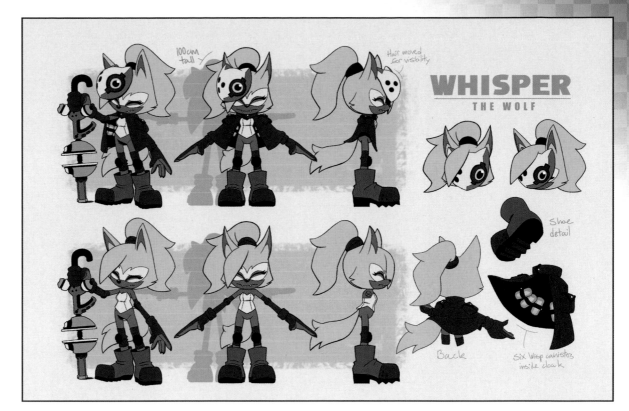

WHISPER
THE WOLF

100cm tall

Hair moved for visibility

Back

Shoe detail

Six Wisp canisters inside cloak

WHISPER CHARACTER DESIGNS AND CONCEPTS BY **EVAN STANLEY**

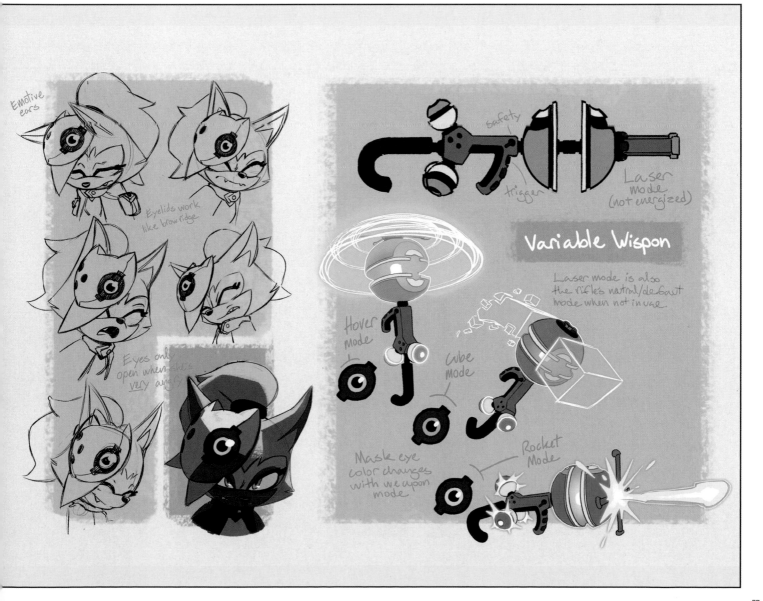

Emotive ears

Eyelids work like brow ridge

Eyes only open when she's very angry

safety

trigger

Laser mode (not energized)

Variable Wispon

Laser mode is also the rifle's natural/default mode when not in use.

Hover Mode

Cube Mode

Rocket Mode

Mask eye color changes with weapon mode

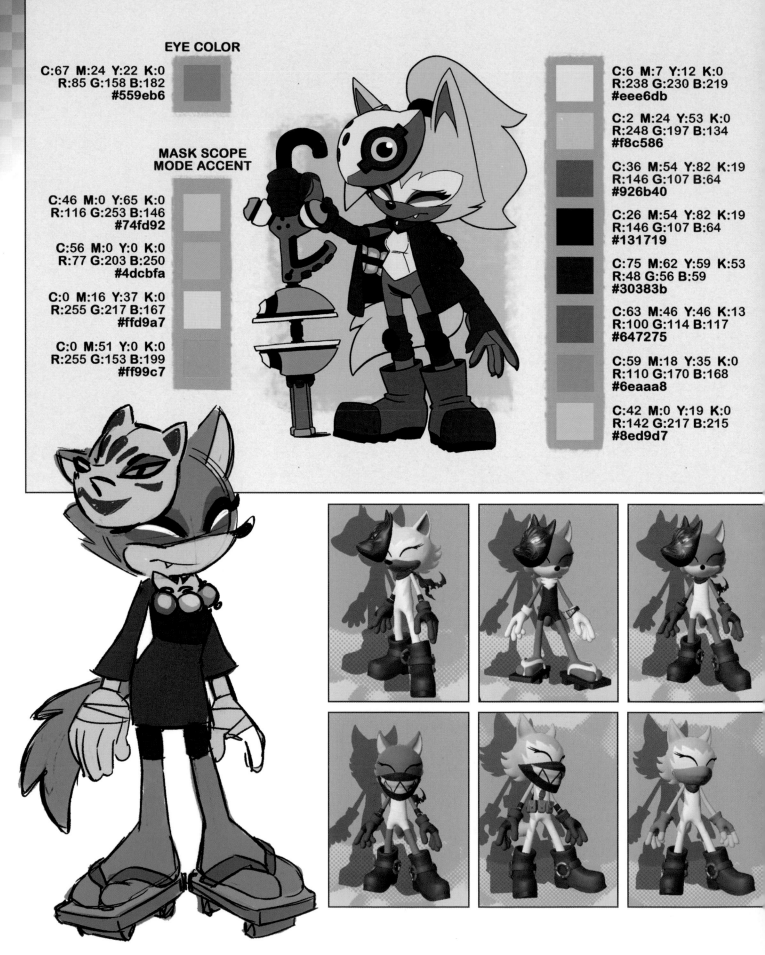

EYE COLOR

C:67 M:24 Y:22 K:0
R:85 G:158 B:182
#559eb6

MASK SCOPE MODE ACCENT

C:46 M:0 Y:65 K:0
R:116 G:253 B:146
#74fd92

C:56 M:0 Y:0 K:0
R:77 G:203 B:250
#4dcbfa

C:0 M:16 Y:37 K:0
R:255 G:217 B:167
#ffd9a7

C:0 M:51 Y:0 K:0
R:255 G:153 B:199
#ff99c7

C:6 M:7 Y:12 K:0
R:238 G:230 B:219
#eee6db

C:2 M:24 Y:53 K:0
R:248 G:197 B:134
#f8c586

C:36 M:54 Y:82 K:19
R:146 G:107 B:64
#926b40

C:26 M:54 Y:82 K:19
R:146 G:107 B:64
#131719

C:75 M:62 Y:59 K:53
R:48 G:56 B:59
#30383b

C:63 M:46 Y:46 K:13
R:100 G:114 B:117
#647275

C:59 M:18 Y:35 K:0
R:110 G:170 B:168
#6eaaa8

C:42 M:0 Y:19 K:0
R:142 G:217 B:215
#8ed9d7

WHISPER CHARACTER DESIGNS AND
CONCEPTS BY **EVAN STANLEY**

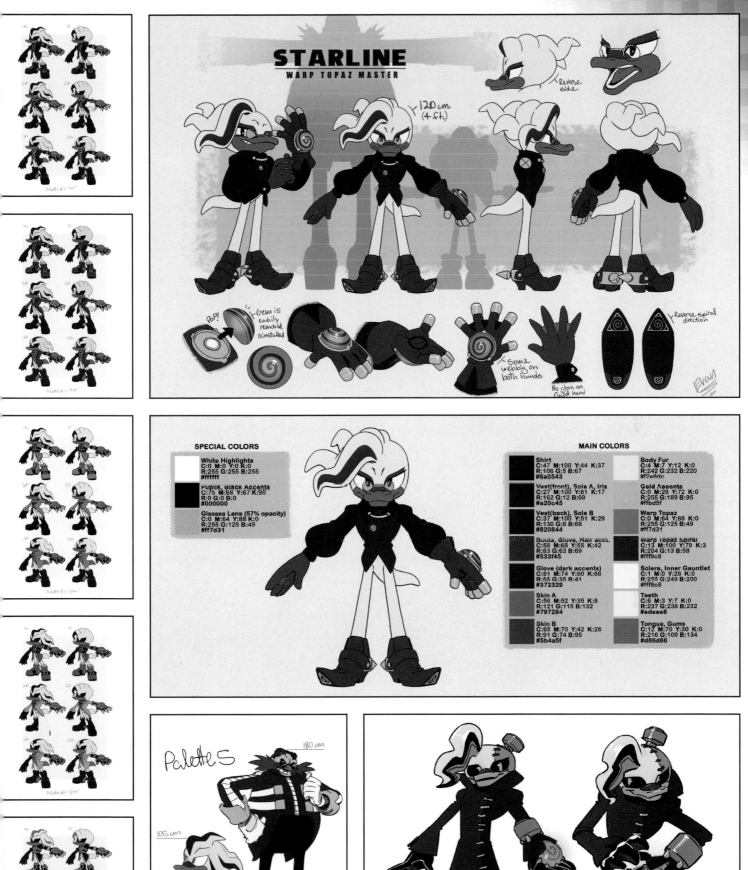

STARLINE
WARP TOPAZ MASTER

↑ 120 cm. (4 ft.)

← Reverse side

PoP! ← Gem is easily removed, reinstalled

← Some webbing on both hands

No glove on right hand

← Reverse spiral direction

Evan

SPECIAL COLORS

White Highlights
C:0 M:0 Y:0 K:0
R:255 G:255 B:255
#ffffff

Pupils, Black Accents
C:75 M:68 Y:67 K:90
R:0 G:0 B:0
#000000

Glasses Lens (57% opacity)
C:0 M:64 Y:88 K:0
R:255 G:125 B:49
#ff7d31

MAIN COLORS

Shirt
C:47 M:100 Y:44 K:37
R:106 G:5 B:67
#6a0543

Vest(front), Sole A, Iris
C:27 M:100 Y:61 K:17
R:162 G:12 B:69
#a20c45

Vest(back), Sole B
C:37 M:100 Y:51 K:29
R:130 G:8 B:68
#820844

Boots, Glove, Hair accel.
C:58 M:68 Y:55 K:42
R:83 G:63 B:69
#533f45

Glove (dark accents)
C:61 M:74 Y:60 K:66
R:55 G:35 B:41
#372329

Skin A
C:56 M:52 Y:35 K:8
R:121 G:115 B:132
#797284

Skin B
C:65 M:70 Y:42 K:26
R:91 G:74 B:95
#5b4a5f

Body Fur
C:4 M:7 Y:12 K:0
R:242 G:232 B:220
#f2e8dc

Gold Accents
C:0 M:29 Y:72 K:0
R:255 G:189 B:95
#ffbd5f

Warp Topaz
C:0 M:64 Y:88 K:0
R:255 G:125 B:49
#ff7d31

Warp Topaz Spiral
C:13 M:100 Y:79 K:3
R:204 G:13 B:58
#fff9c8

Sclera, Inner Gauntlet
C:1 M:0 Y:26 K:0
R:255 G:249 B:200
#fff9c8

Teeth
C:6 M:3 Y:7 K:0
R:237 G:238 B:232
#edeee8

Tongue, Gums
C:12 M:70 Y:30 K:0
R:216 G:109 B:134
#d86d86

Palette 5

180 cm

105 cm

1B

DR. STARLINE CHARACTER DESIGNS
AND CONCEPTS BY **EVAN STANLEY**

29

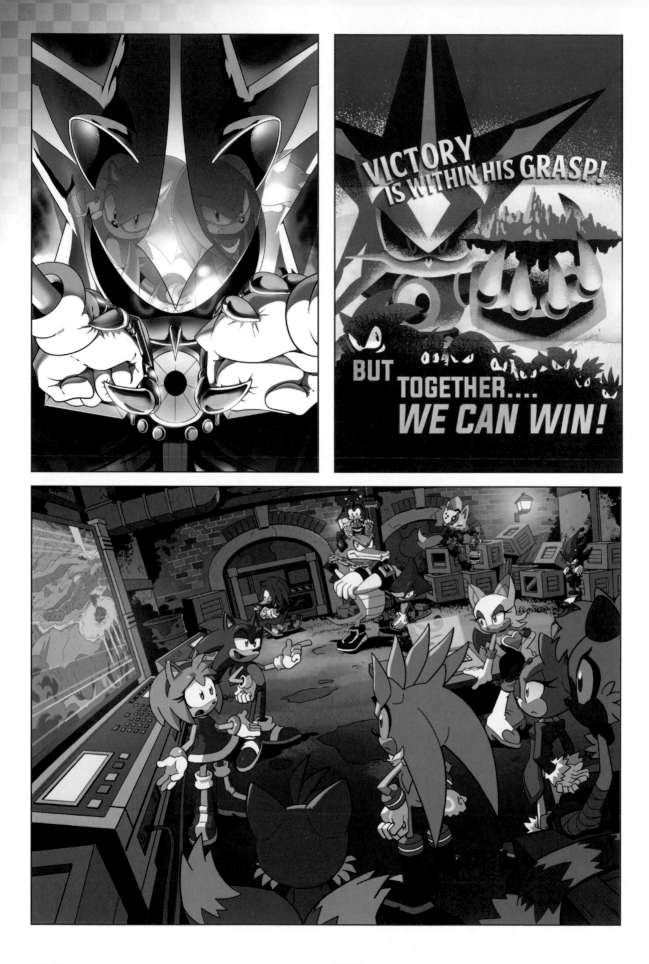

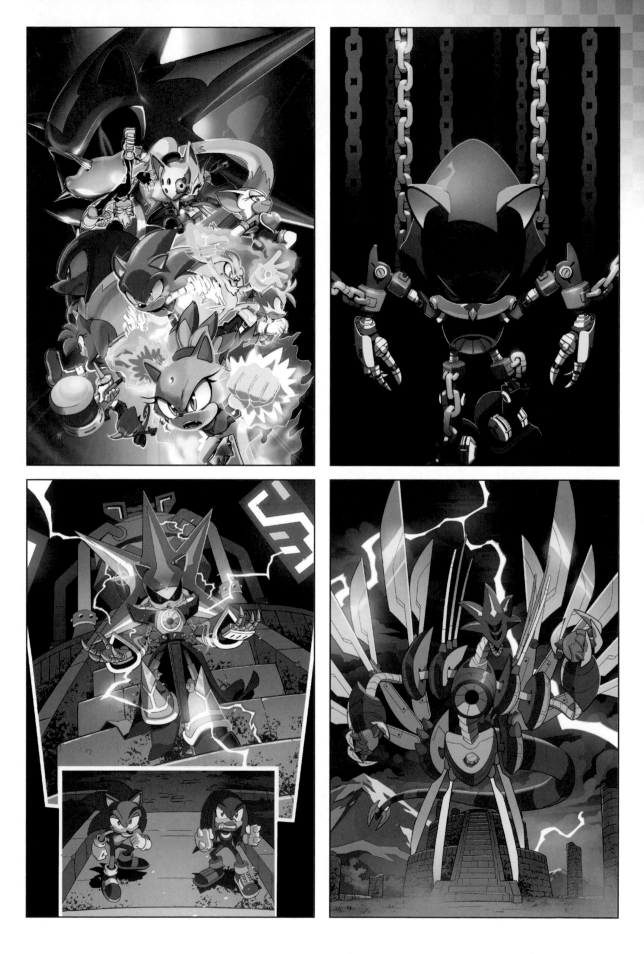

TOP LEFT
SONIC THE HEDGEHOG #10
COVER A
ART BY **ADAM BRYCE THOMAS**

TOP RIGHT
SONIC THE HEDGEHOG #12
COVER B
ART BY **EVAN STANLEY**
COLORS BY **MATT HERMS**

BOTTOM LEFT
SONIC THE HEDGEHOG #10
PAGE 1
ART BY **TRACY YARDLEY**
COLORS BY **MATT HERMS**

BOTTOM RIGHT
SONIC THE HEDGEHOG #10
PAGE 20
ART BY **TRACY YARDLEY**
COLORS BY **MATT HERMS**

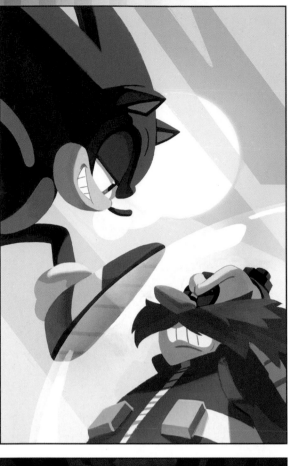

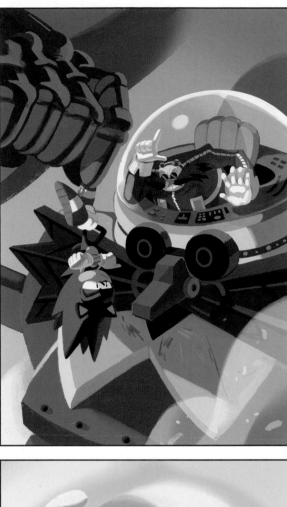

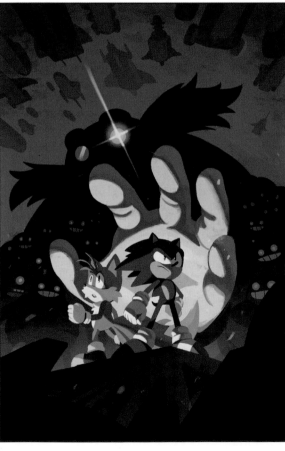

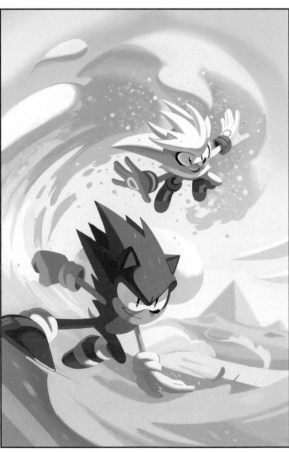

TOP LEFT
SONIC THE HEDGEHOG #5
INCENTIVE COVER
ART BY **NATHALIE FOURDRAINE**

TOP RIGHT
SONIC THE HEDGEHOG #6
INCENTIVE COVER
ART BY **NATHALIE FOURDRAINE**

BOTTOM LEFT
SONIC THE HEDGEHOG #7
INCENTIVE COVER
ART BY **NATHALIE FOURDRAINE**

BOTTOM RIGHT
SONIC THE HEDGEHOG #8
INCENTIVE COVER
ART BY **NATHALIE FOURDRAINE**

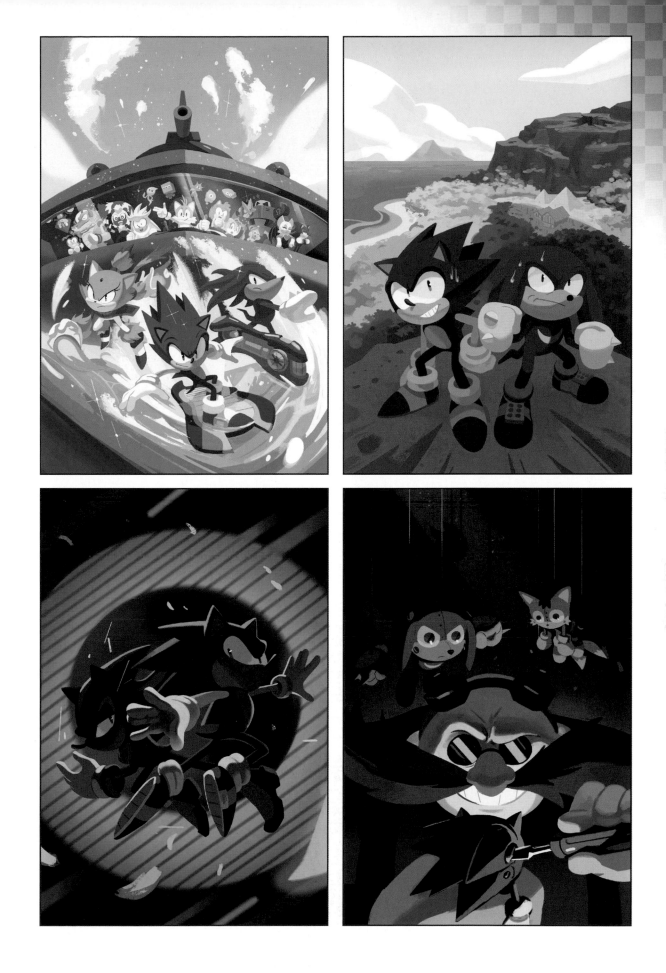

TOP LEFT
SONIC THE HEDGEHOG #9
INCENTIVE COVER
ART BY **NATHALIE FOURDRAINE**

TOP RIGHT
SONIC THE HEDGEHOG #10
INCENTIVE COVER
ART BY **NATHALIE FOURDRAINE**

BOTTOM LEFT
SONIC THE HEDGEHOG #11
INCENTIVE COVER
ART BY **NATHALIE FOURDRAINE**

BOTTOM RIGHT
SONIC THE HEDGEHOG #12
INCENTIVE COVER
ART BY **NATHALIE FOURDRAINE**

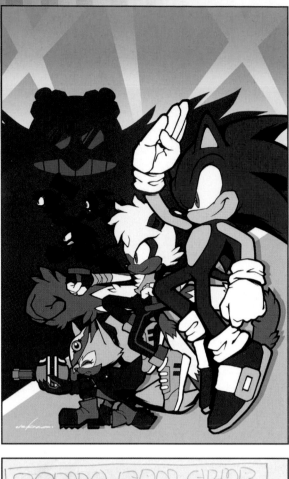

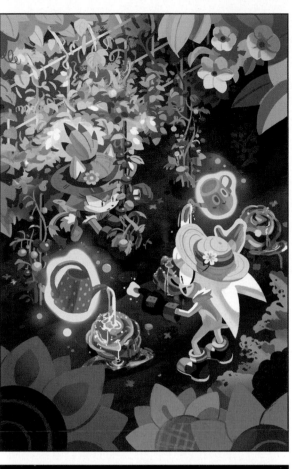

TOP LEFT
SONIC THE HEDGEHOG
2019 ANNUAL
COVER A
ART BY **YUJI UEKAWA** OF SONIC TEAM

TOP RIGHT
SONIC THE HEDGEHOG
2019 ANNUAL
INCENTIVE COVER
ART BY **NATHALIE FOURDRAINE**

BOTTOM LEFT
SONIC THE HEDGEHOG
2019 ANNUAL
PAGE 35
LAYOUT BY **JAMES KOCHALKA**

BOTTOM RIGHT
SONIC THE HEDGEHOG
2019 ANNUAL
PAGE 35
ART BY **JONATHAN GRAY**
COLORS BY **REGGIE GRAHAM**

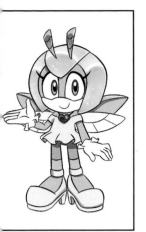

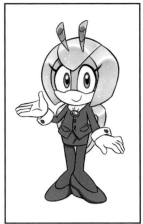

JEWEL CHARACTER DESIGNS
AND CONCEPTS BY **JENNIFER HERNANDEZ**

DIAMOND CUTTERS CHARACTER DESIGNS
AND CONCEPTS BY **EVAN STANLEY**

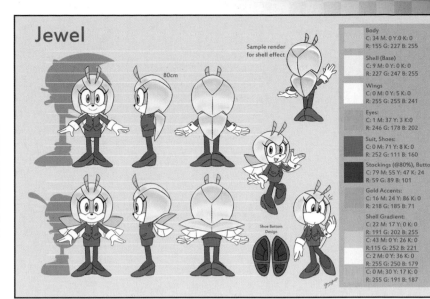

Jewel

Sample render
for shell effect

80cm

Shoe Bottom
Design

Body
C: 34 M: 0 Y: 0 K: 0
R: 155 G: 227 B: 255

Shell (Base)
C: 9 M: 0 Y: 0 K: 0
R: 227 G: 247 B: 255

Wings
C: 0 M: 0 Y: 5 K: 0
R: 255 G: 255 B: 241

Eyes:
C: 1 M: 37 Y: 3 K: 0
R: 246 G: 178 B: 202

Suit, Shoes:
C: 0 M: 71 Y: 8 K: 0
R: 252 G: 111 B: 160

Stockings (@80%), Buttons:
C: 79 M: 55 Y: 47 K: 24
R: 59 G: 89 B: 101

Gold Accents:
C: 16 M: 24 Y: 86 K: 0
R: 218 G: 185 B: 71

Shell Gradient:
C: 22 M: 17 Y: 0 K: 0
R: 191 G: 202 B: 255
C: 43 M: 0 Y: 26 K: 0
R: 115 G: 252 B: 221
C: 2 M: 0 Y: 36 K: 0
R: 255 G: 250 B: 179
C: 0 M: 30 Y: 17 K: 0
R: 255 G: 191 B: 187

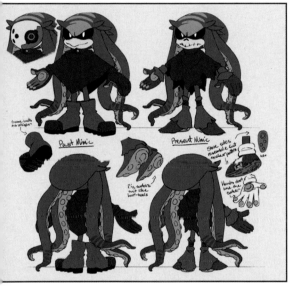

Past Mimic *Present Mimic*

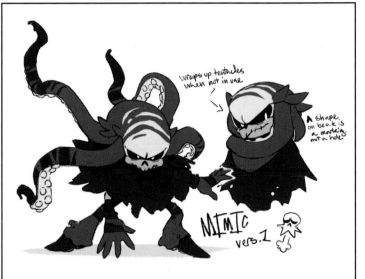

wraps up tentacles
when not in use

A shape
on beak is
a marking
not a hole!

MIMIC
vers. 1

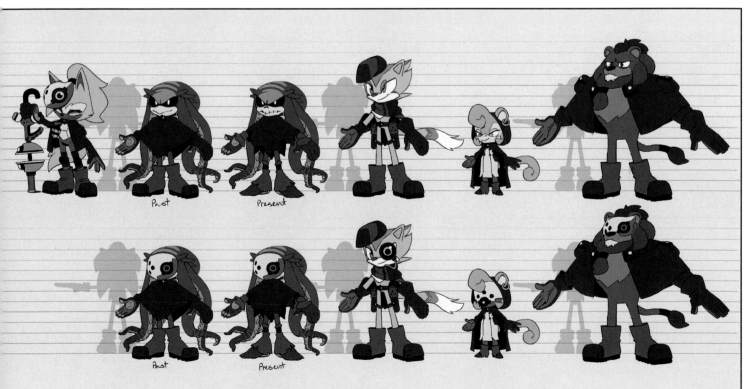

Past *Present*

Past *Present*

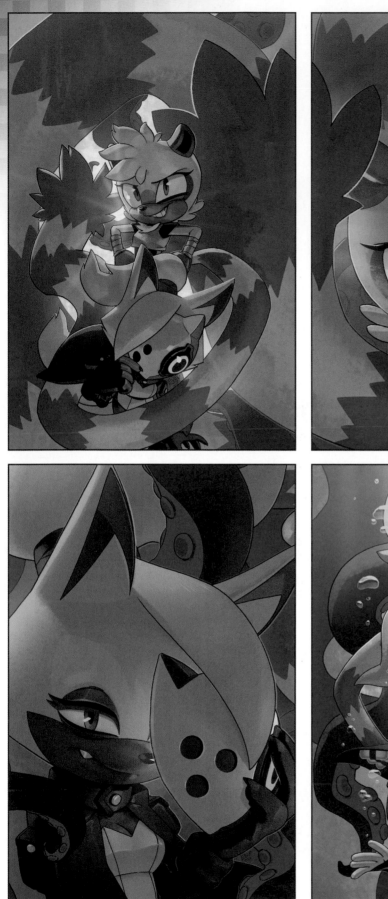

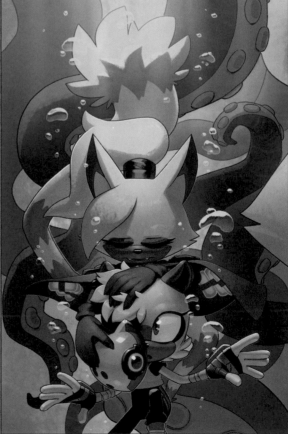

SONIC THE HEDGEHOG:
TANGLE AND WHISPER #1-4
COVER A
ART BY EVAN STANLEY

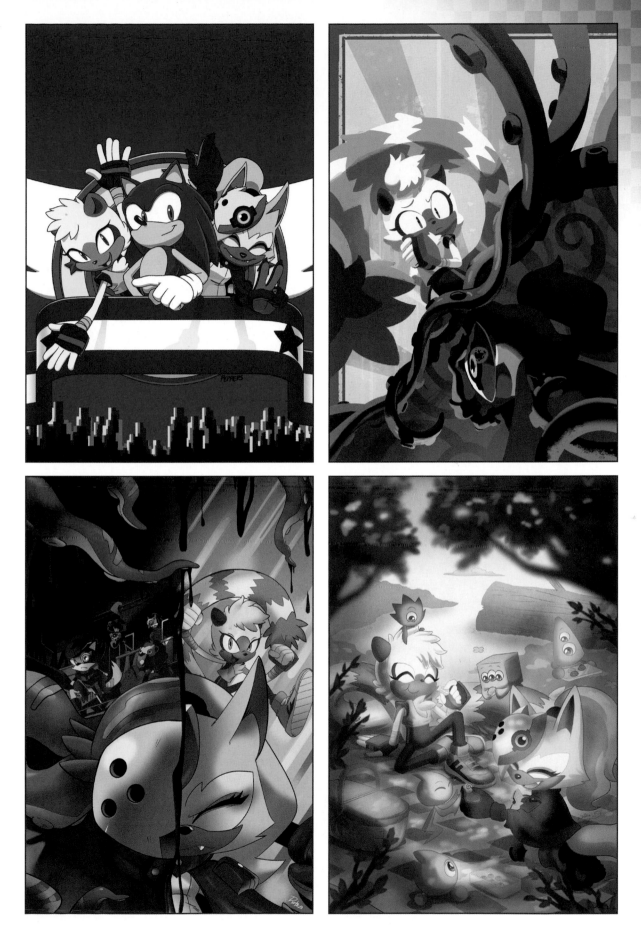

TOP LEFT
**SONIC THE HEDGEHOG:
TANGLE AND WHISPER #0**
EXCLUSIVE COVER
ART BY **JAMAL PEPPERS**

TOP RIGHT
**SONIC THE HEDGEHOG:
TANGLE AND WHISPER #2**
COVER B
ART BY **NATHALIE FOURDRAINE**

BOTTOM LEFT
**SONIC THE HEDGEHOG:
TANGLE AND WHISPER #3**
INCENTIVE COVER
ART BY **PRISCILLA TRAMONTANO**

BOTTOM RIGHT
**SONIC THE HEDGEHOG:
TANGLE AND WHISPER #4**
INCENTIVE COVER
ART BY **ABIGAIL STARLING**

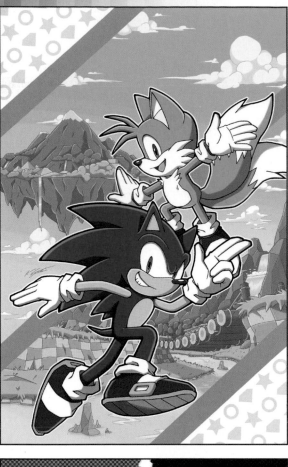

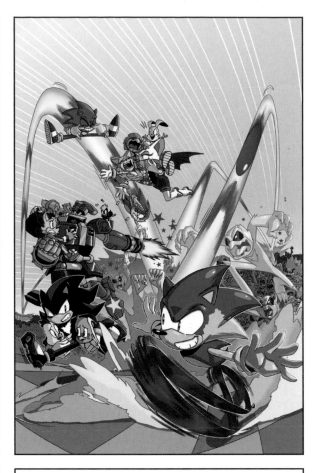

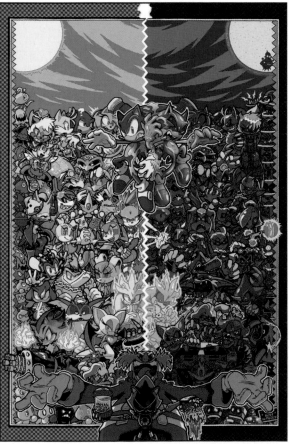

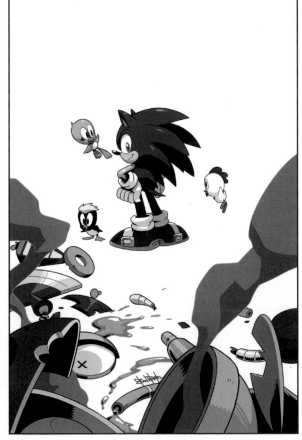

TOP LEFT
SONIC THE HEDGEHOG #13
COVER B
ART BY KIERAN GATES

TOP RIGHT
SONIC THE HEDGEHOG #19
COVER A
ART BY RYAN JAMPOLE

BOTTOM LEFT
SONIC THE HEDGEHOG #24
COVER A
ART BY JONATHAN GRAY
COLORS BY REGGIE GRAHAM

BOTTOM RIGHT
SONIC THE HEDGEHOG #27
EXCLUSIVE COVER
ART BY BEN BATES

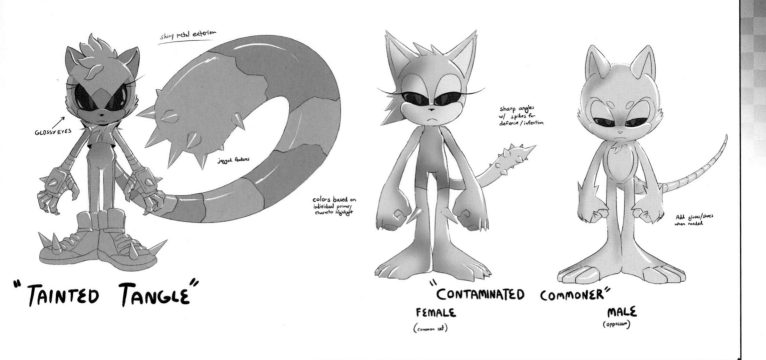

"TAINTED TANGLE"

shiny metal exterior

GLOSSY EYES

jagged features

"CONTAMINATED COMMONER"

FEMALE
(common cat)

MALE
(opossum)

sharp angles w/ spikes for defense / infection

colors based on individual primary character highlight

Add gloves/shoes when needed

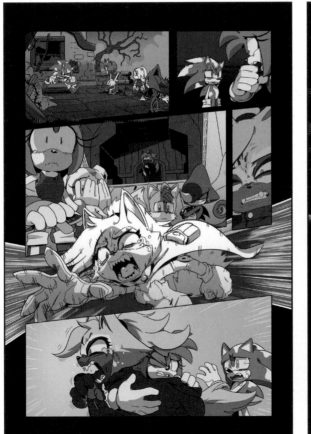

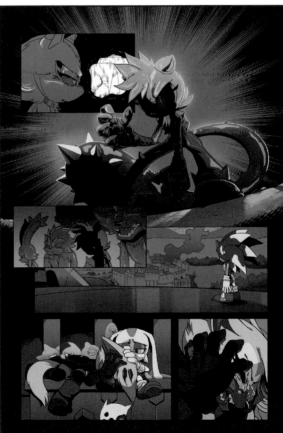

TOP
METAL VIRUS CHARACTER
DESIGNS AND CONCEPTS BY
ADAM BRYCE THOMAS

BOTTOM LEFT
SONIC THE HEDGEHOG #24
PAGE 16
ART BY **ADAM BRYCE THOMAS**
COLORS BY **BRACARDI CURRY**

BOTTOM RIGHT
SONIC THE HEDGEHOG #24
PAGE 19
ART BY **ADAM BRYCE THOMAS**
COLORS BY **BRACARDI CURRY**

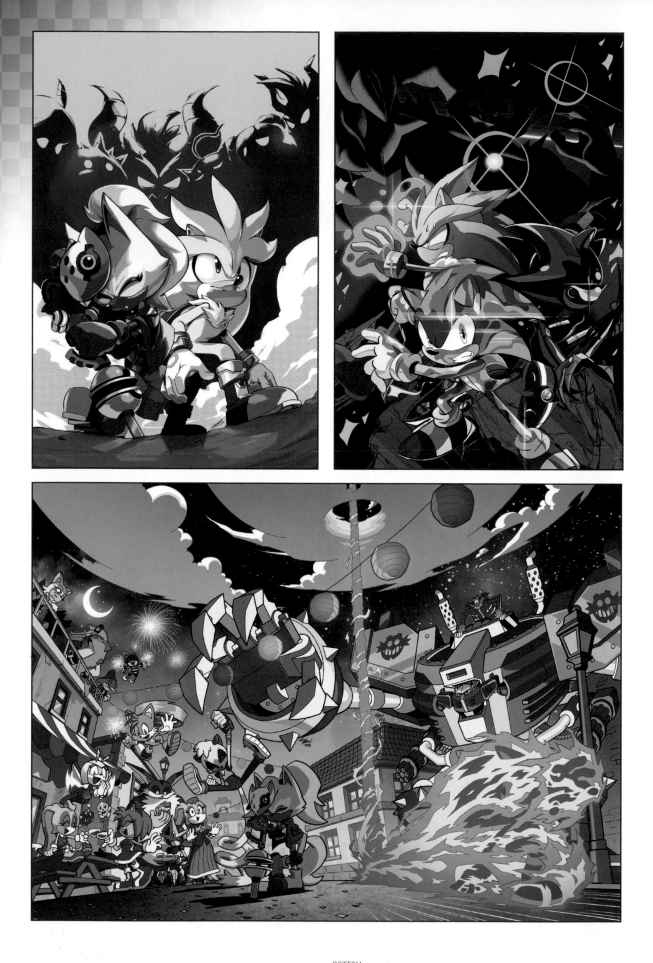

TOP LEFT
SONIC THE HEDGEHOG #28
COVER B
ART BY **BRACARDI CURRY**

TOP RIGHT
SONIC THE HEDGEHOG #29
COVER B
ART BY **PRISCILLA TRAMONTANO**

BOTTOM
SONIC THE HEDGEHOG #31-32
COVER A CONNECTING
ART BY **TRACY YARDLEY**
COLORS BY **LEONARDO ITO**

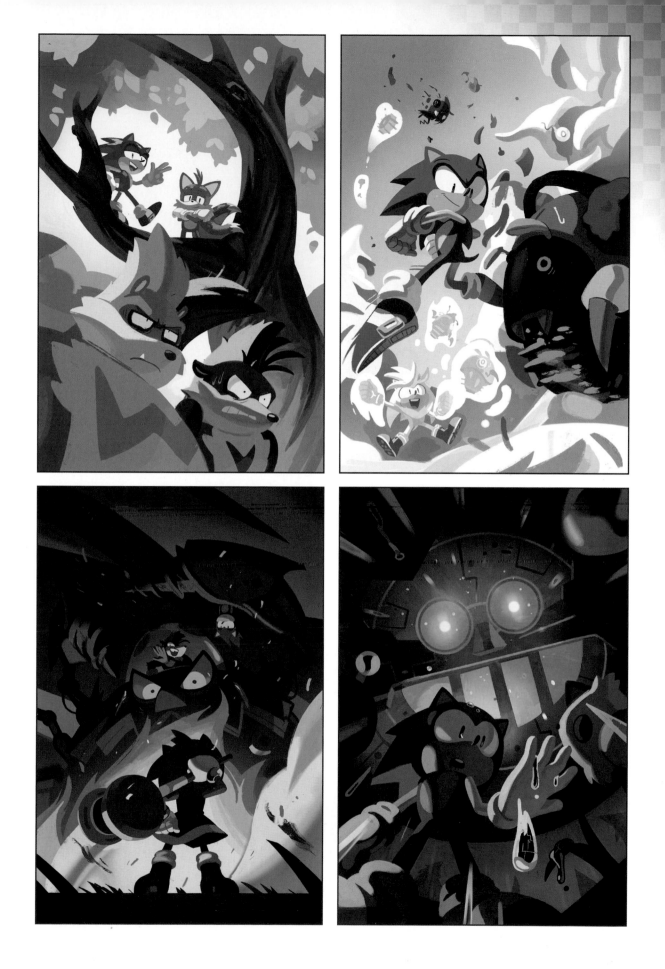

TOP LEFT
SONIC THE HEDGEHOG #13
INCENTIVE COVER
ART BY **NATHALIE FOURDRAINE**

TOP RIGHT
SONIC THE HEDGEHOG #14
INCENTIVE COVER
ART BY **NATHALIE FOURDRAINE**

BOTTOM LEFT
SONIC THE HEDGEHOG #15
INCENTIVE COVER
ART BY **NATHALIE FOURDRAINE**

BOTTOM RIGHT
SONIC THE HEDGEHOG #16
INCENTIVE COVER
ART BY **NATHALIE FOURDRAINE**

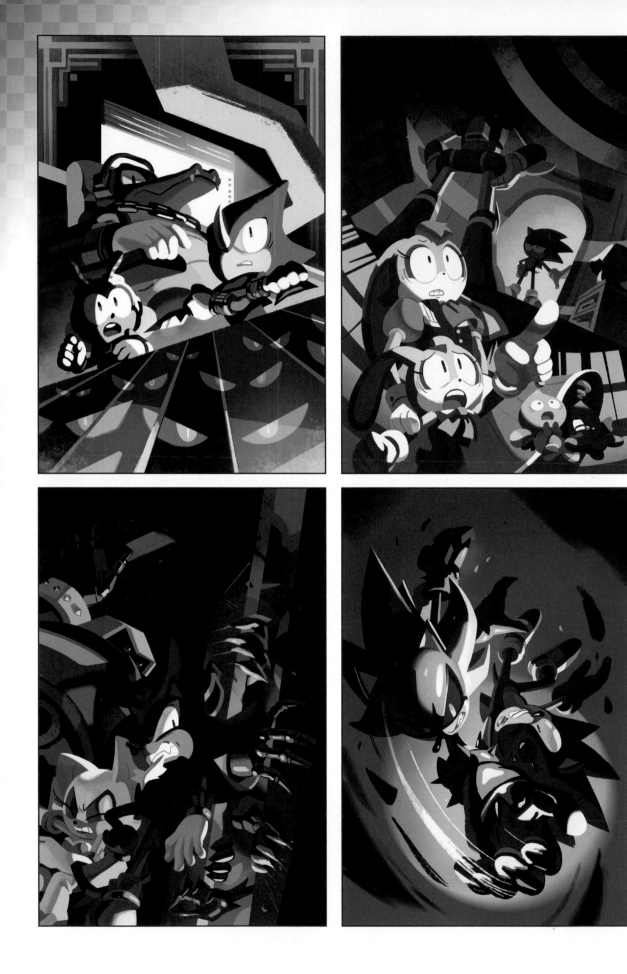

TOP LEFT
SONIC THE HEDGEHOG #17
INCENTIVE COVER
ART BY **NATHALIE FOURDRAINE**

TOP RIGHT
SONIC THE HEDGEHOG #18
INCENTIVE COVER
ART BY **NATHALIE FOURDRAINE**

BOTTOM LEFT
SONIC THE HEDGEHOG #19
INCENTIVE COVER
ART BY **NATHALIE FOURDRAINE**

BOTTOM RIGHT
SONIC THE HEDGEHOG #20
INCENTIVE COVER
ART BY **NATHALIE FOURDRAINE**

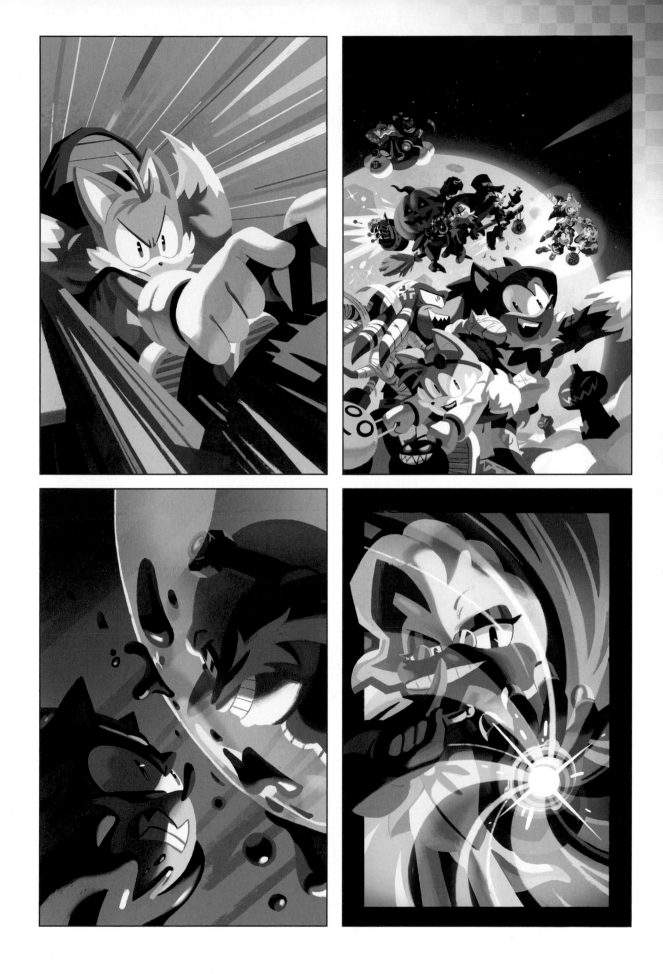

TOP LEFT
SONIC THE HEDGEHOG #21
INCENTIVE COVER
ART BY **NATHALIE FOURDRAINE**

TOP RIGHT
SONIC THE HEDGEHOG #22
INCENTIVE COVER
ART BY **NATHALIE FOURDRAINE**

BOTTOM LEFT
SONIC THE HEDGEHOG #23
INCENTIVE COVER
ART BY **NATHALIE FOURDRAINE**

BOTTOM RIGHT
SONIC THE HEDGEHOG #24
INCENTIVE COVER
ART BY **NATHALIE FOURDRAINE**

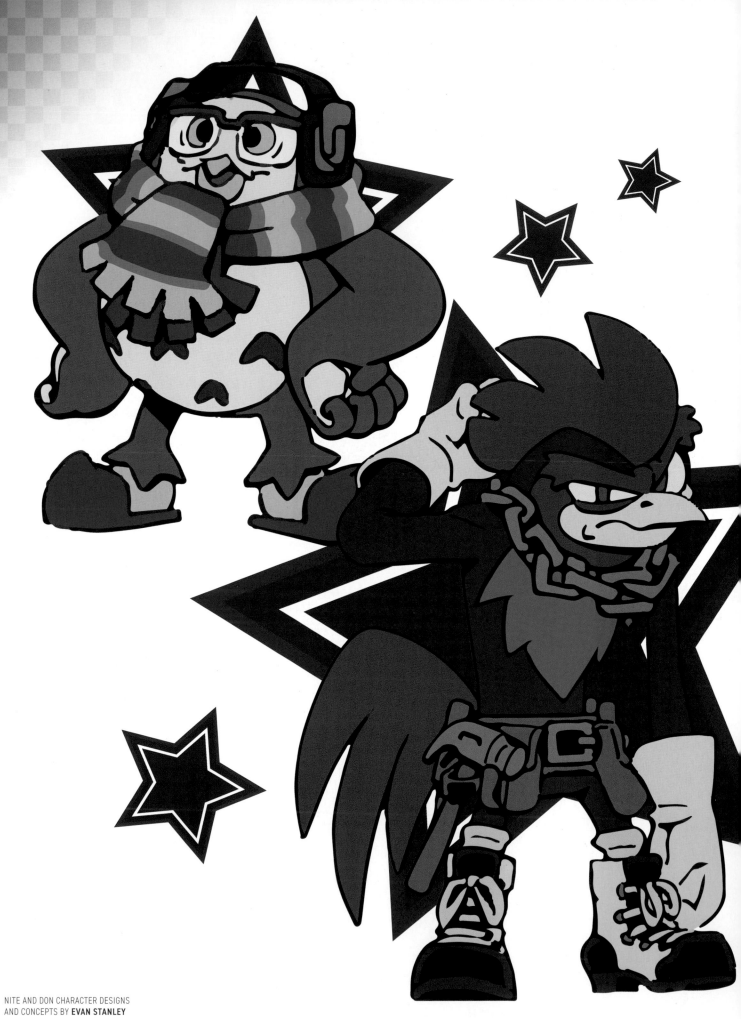

NITE AND DON CHARACTER DESIGNS
AND CONCEPTS BY **EVAN STANLEY**

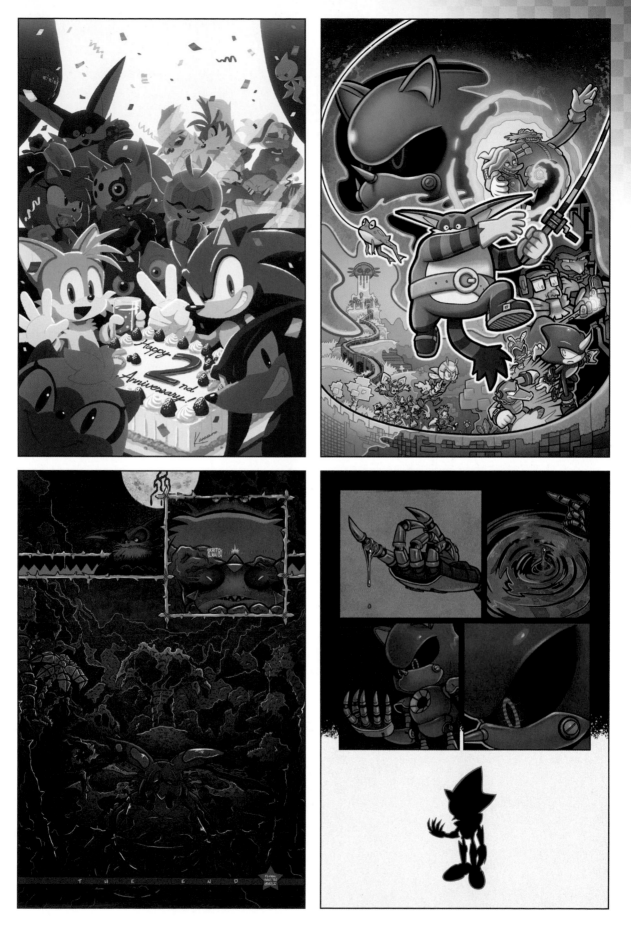

TOP LEFT
SONIC THE HEDGEHOG 2020 ANNUAL
COVER A
ART BY YUI KARASUNO OF SONIC TEAM

TOP RIGHT
SONIC THE HEDGEHOG 2020 ANNUAL
EXCLUSIVE COVER
ART BY REGGIE GRAHAM

BOTTOM LEFT
SONIC THE HEDGEHOG 2020 ANNUAL
PAGE 10
ART BY JONATHAN GRAY
COLORS BY REGGIE GRAHAM

BOTTOM RIGHT
SONIC THE HEDGEHOG 2020 ANNUAL
PAGE 21
PENCILS BY AARON HAMMERSTROM
INKS & COLORS BY REGGIE GRAHAM

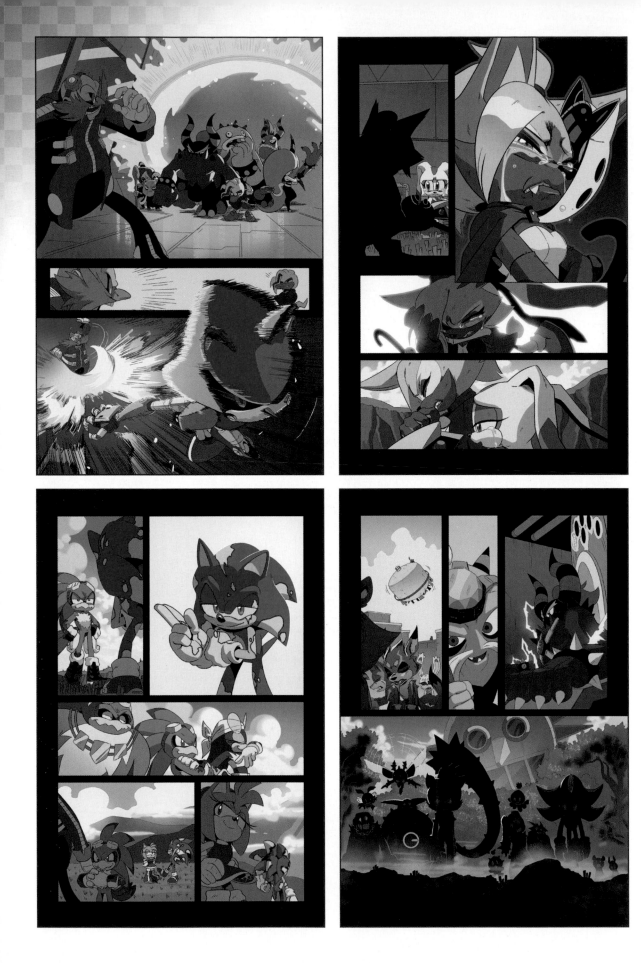

TOP LEFT
SONIC THE HEDGEHOG #25
PAGE 3
ART BY **ADAM BRYCE THOMAS**
COLORS BY **MATT HERMS**

TOP RIGHT
SONIC THE HEDGEHOG #25
PAGE 14
ART BY **ADAM BRYCE THOMAS**
COLORS BY **MATT HERMS**

BOTTOM LEFT
SONIC THE HEDGEHOG #25
PAGE 21
ART BY **ADAM BRYCE THOMAS**
COLORS BY **MATT HERMS**

BOTTOM RIGHT
SONIC THE HEDGEHOG #25
PAGE 24
ART BY **ADAM BRYCE THOMAS**
COLORS BY **MATT HERMS**

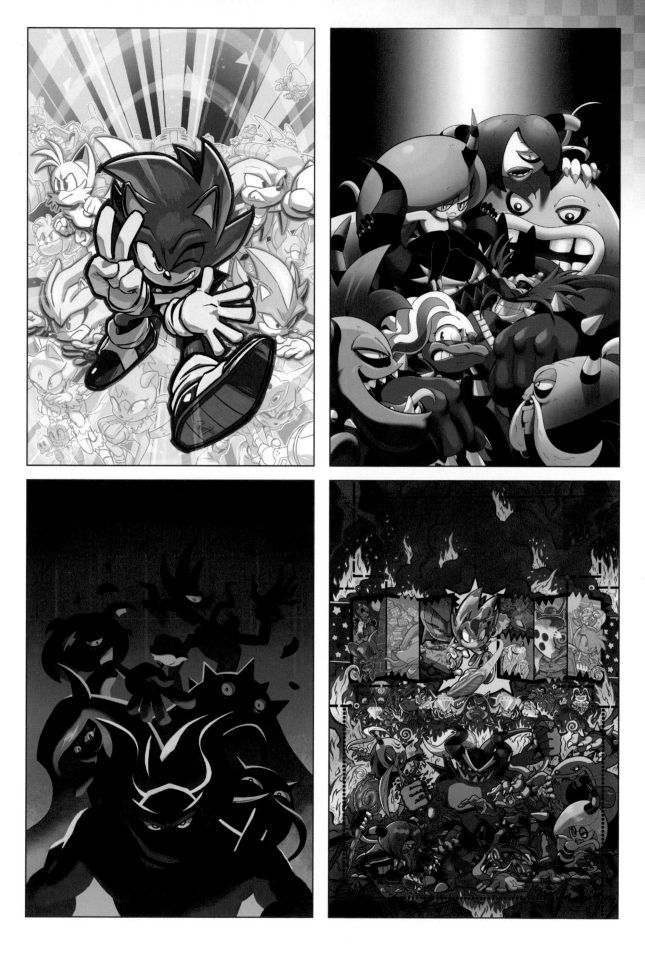

TOP LEFT
SONIC THE HEDGEHOG #25
COVER A
ART BY TYSON HESSE

TOP RIGHT
SONIC THE HEDGEHOG #25
COVER B
ART BY ADAM BRYCE THOMAS

BOTTOM LEFT
SONIC THE HEDGEHOG #25
INCENTIVE COVER
ART BY NATHALIE FOURDRAINE

BOTTOM RIGHT
SONIC THE HEDGEHOG #25
INCENTIVE COVER
ART BY JONATHAN GRAY
COLORS BY REGGIE GRAHAM

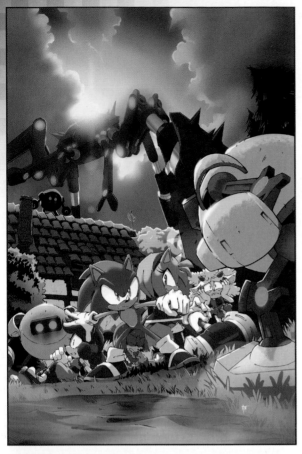

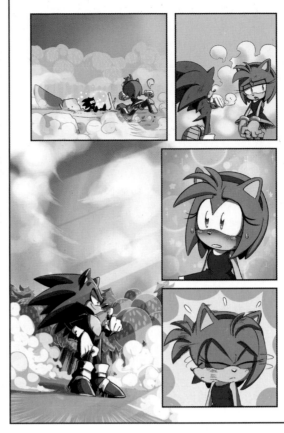

ADAM BRYCE THOMAS JOINED THE SERIES WITH ISSUE #2, PENCILING, INKING, AND COLORING THAT ISSUE. ENJOY A SELECTION OF HIS AND OUR FAVORITE PIECES.

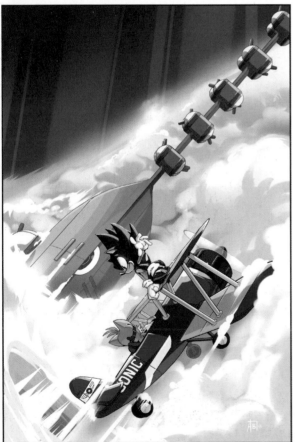

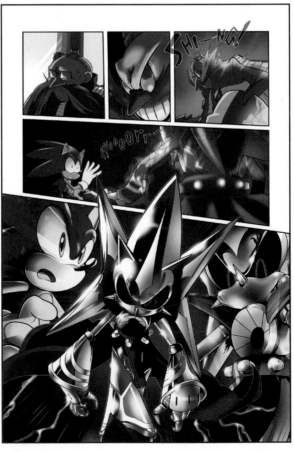

TOP LEFT
SONIC THE HEDGEHOG #2
COVER B

TOP RIGHT
SONIC THE HEDGEHOG #2
PAGE 18

BOTTOM LEFT
SONIC THE HEDGEHOG #7
COVER B

BOTTOM RIGHT
SONIC THE HEDGEHOG #7
PAGE 5

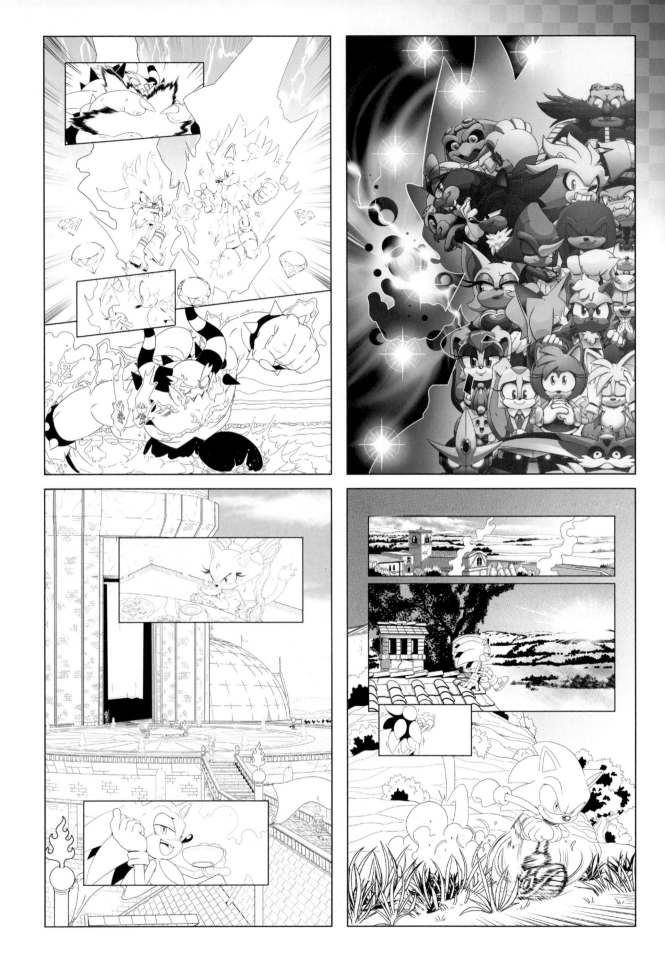

TOP LEFT
SONIC THE HEDGEHOG #29
PAGE 12
PENCILS & INKS

TOP RIGHT
SONIC THE HEDGEHOG #30
COVER A

BOTTOM LEFT
SONIC THE HEDGEHOG #31
PAGE 1
PENCILS & INKS

BOTTOM RIGHT
SONIC THE HEDGEHOG #32
PAGE 20
PENCILS & INKS

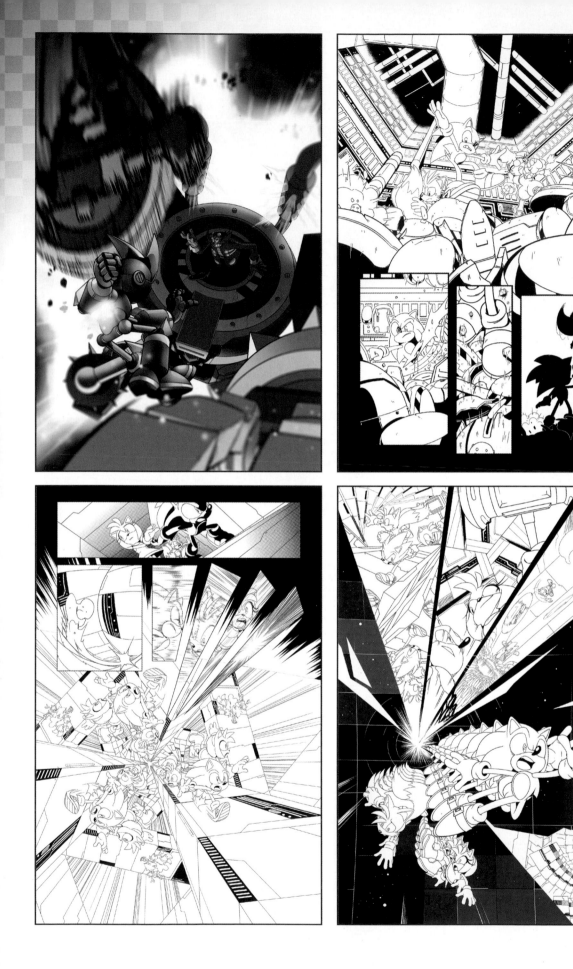

TOP LEFT
SONIC THE HEDGEHOG #32
COVER B

TOP RIGHT
SONIC THE HEDGEHOG #35
PAGE 1
PENCILS & INKS

BOTTOM LEFT
SONIC THE HEDGEHOG #37
PAGE 19
PENCILS & INKS

BOTTOM RIGHT
SONIC THE HEDGEHOG #37
PAGE 20
PENCILS & INKS

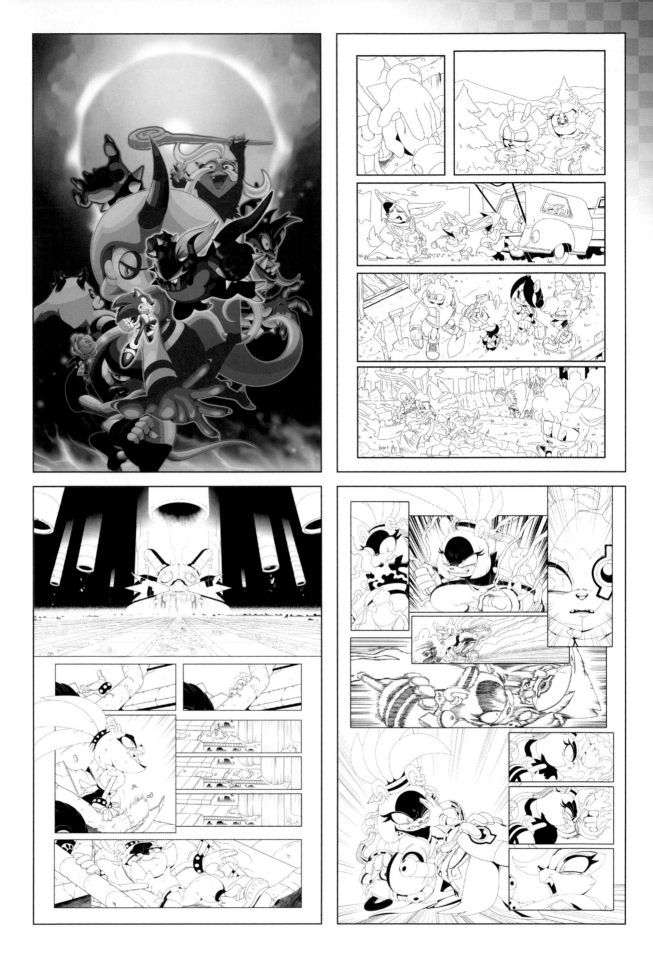

TOP LEFT
SONIC THE HEDGEHOG #41
COVER A

TOP RIGHT
SONIC THE HEDGEHOG #46
PAGE 10
PENCILS & INKS

BOTTOM LEFT
SONIC THE HEDGEHOG #51
PAGE 4
PENCILS & INKS

BOTTOM RIGHT
SONIC THE HEDGEHOG #53
PAGE 11
PENCILS & INKS

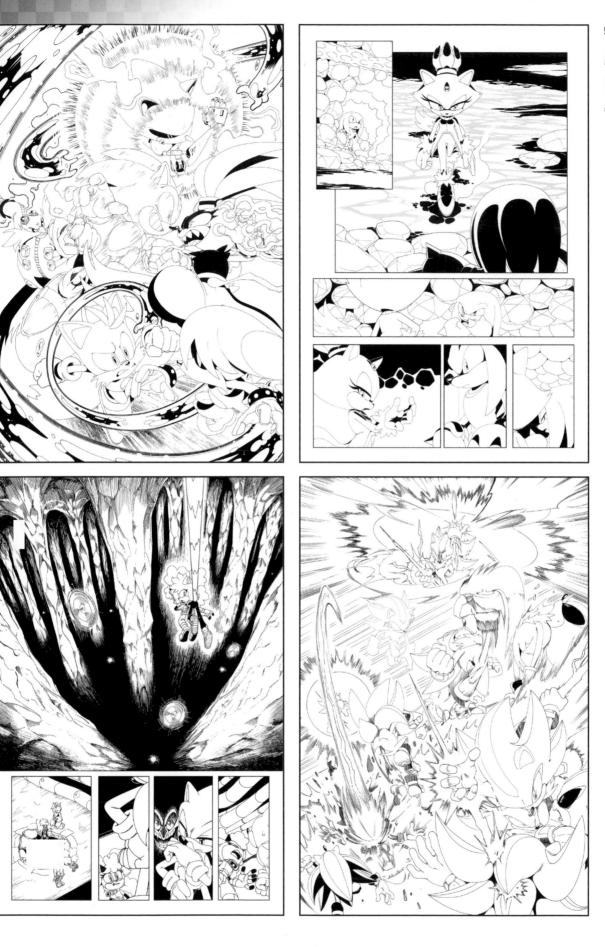

TOP LEFT
SONIC THE HEDGEHOG #55
PAGE 20
PENCILS & INKS

TOP RIGHT
SONIC THE HEDGEHOG ANNUAL 2022
PAGE 4
PENCILS & INKS

BOTTOM LEFT
SONIC THE HEDGEHOG #57
PAGE 14
PENCILS & INKS

BOTTOM RIGHT
SONIC THE HEDGEHOG #59
PAGE 12
PENCILS & INKS

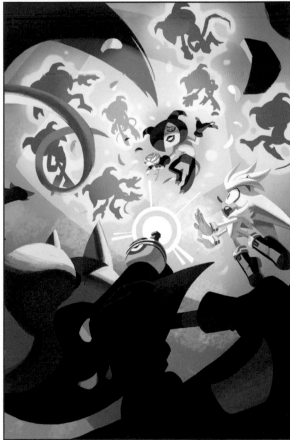

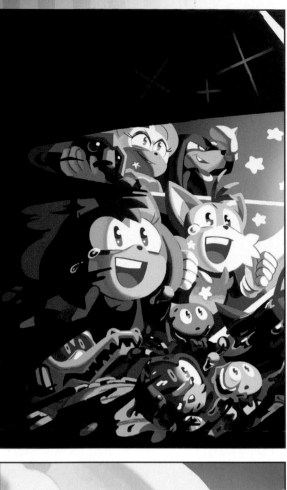

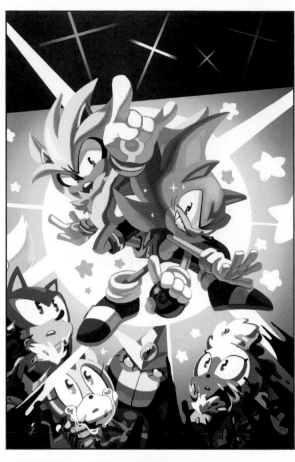

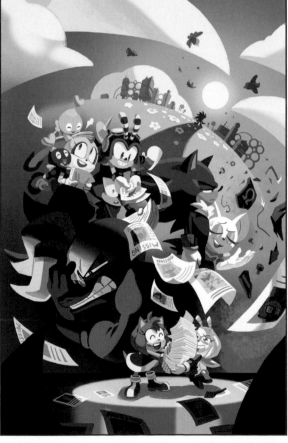

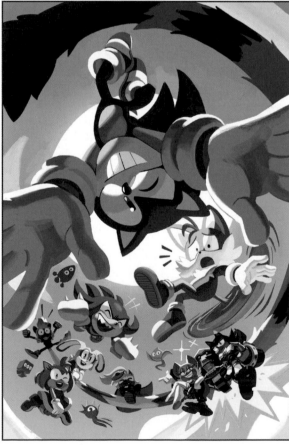

TOP LEFT
SONIC THE HEDGEHOG #29
INCENTIVE COVER
ART BY **NATHALIE FOURDRAINE**

TOP RIGHT
SONIC THE HEDGEHOG #30
INCENTIVE COVER
ART BY **NATHALIE FOURDRAINE**

BOTTOM LEFT
SONIC THE HEDGEHOG #31
INCENTIVE COVER
ART BY **NATHALIE FOURDRAINE**

BOTTOM RIGHT
SONIC THE HEDGEHOG #32
INCENTIVE COVER
ART BY **NATHALIE FOURDRAINE**

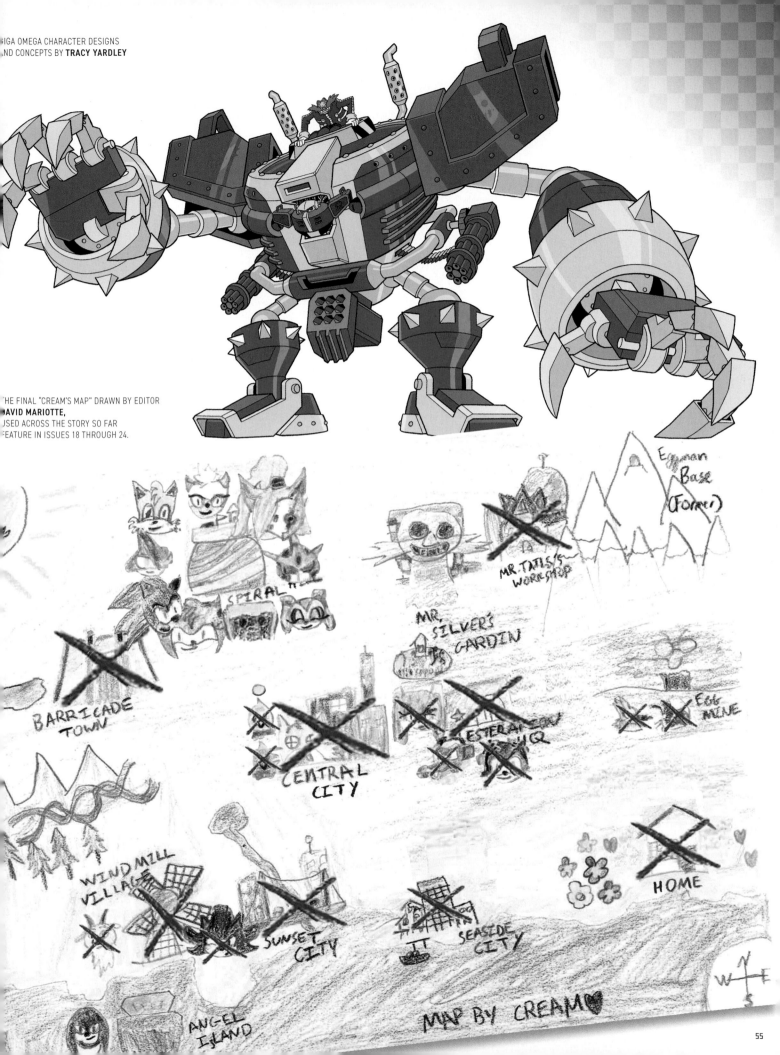

SEGA OMEGA CHARACTER DESIGNS
AND CONCEPTS BY **TRACY YARDLEY**

THE FINAL "CREAM'S MAP" DRAWN BY EDITOR
DAVID MARIOTTE,
USED ACROSS THE STORY SO FAR
FEATURE IN ISSUES 18 THROUGH 24.

Eggman Base (former)

MR. TAILS'S WORKSHOP

MR. SILVER'S GARDEN

SPIRAL

EGG MINE

RESTORATION HQ

BARRICADE TOWN

CENTRAL CITY

HOME

WINDMILL VILLAGE

SUNSET CITY

SEASIDE CITY

ANGEL ISLAND

MAP BY CREAM♥

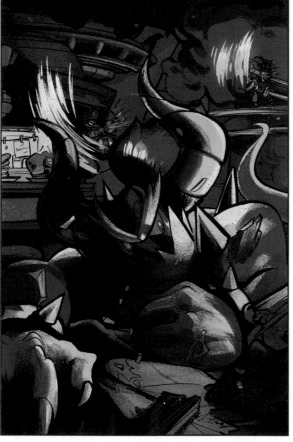
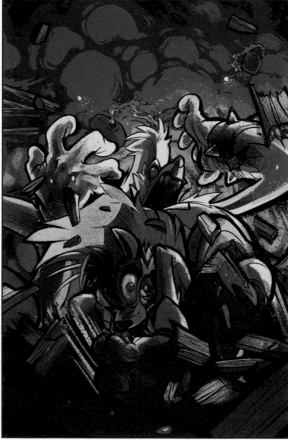

SONIC THE HEDGEHOG:
BAD GUYS #1-4
COVER B CONNECTING
ART BY **DIANA SKELLY**

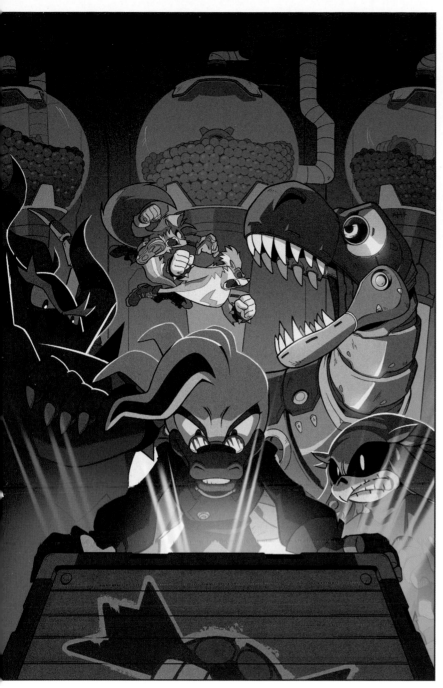

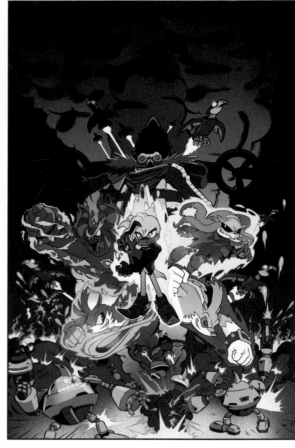

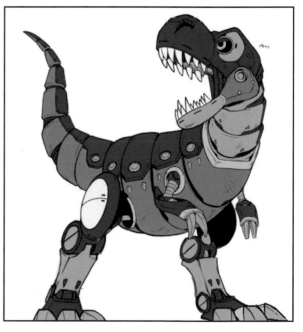

TOP LEFT
**SONIC THE HEDGEHOG:
BAD GUYS #2
COVER A**
ART BY **AARON HAMMERSTROM**
COLORS BY **MATT HERMS**

TOP RIGHT
**SONIC THE HEDGEHOG:
BAD GUYS #4
COVER A**
ART BY **AARON HAMMERSTROM**
COLORS BY **MATT HERMS**

BOTTOM RIGHT
CHARACTER DESIGN AND
CONCEPT BY **AARON HAMMERSTROM**

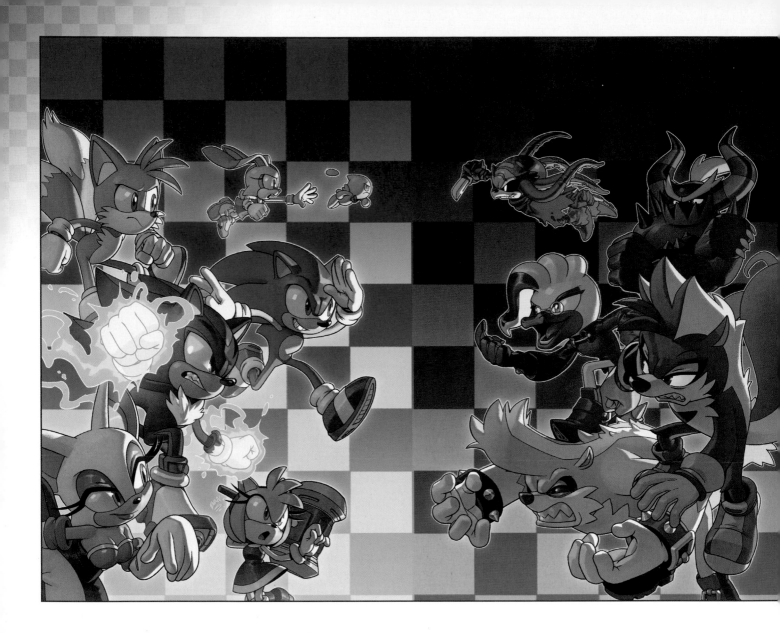

SONIC THE HEDGEHOG #33
& SONIC THE HEDGEHOG:
BAD GUYS #1
EXCLUSIVE CONNECTING COVERS
ART BY EVAN STANLEY

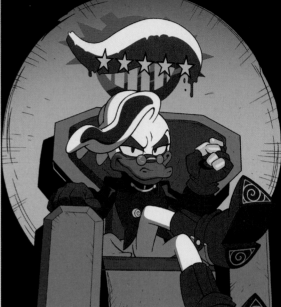

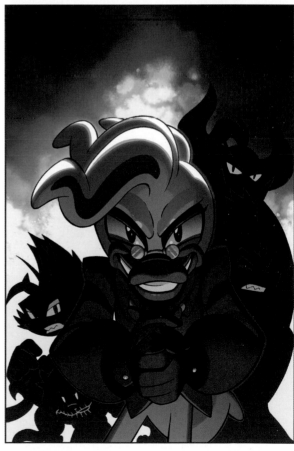

TOP LEFT
**SONIC THE HEDGEHOG:
BAD GUYS #2**
PAGE 2
ART BY JACK LAWRENCE
COLORS BY LEONARDO ITO

TOP RIGHT
**SONIC THE HEDGEHOG:
BAD GUYS #4**
PAGE 20
ART BY JACK LAWRENCE
COLORS BY LEONARDO ITO

BOTTOM RIGHT
**SONIC THE HEDGEHOG:
BAD GUYS #2**
INCENTIVE COVER
ART BY JACK LAWRENCE
COLORS BY LEONARDO ITO

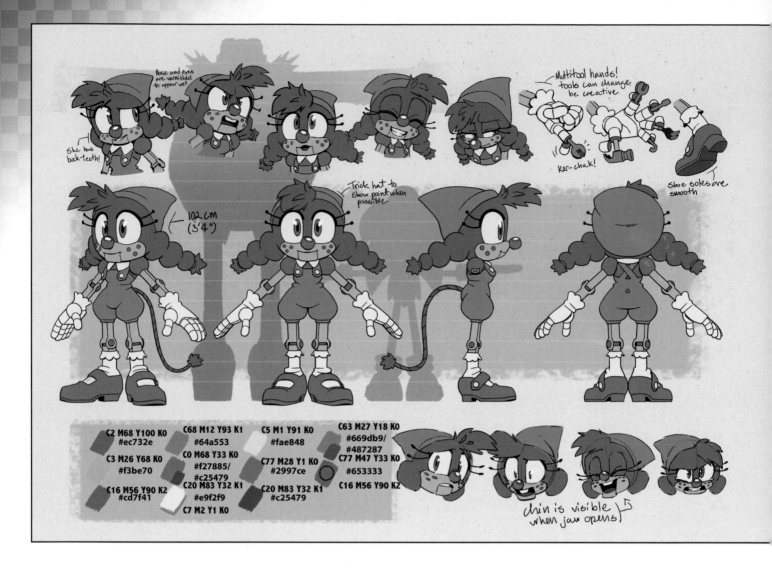

She has buck teeth!

Nose and eyes are varnished to appear wet.

Multitool hands! tools can change, be creative

ker-chak!

Shoe soles are smooth

102 cm (3'4")

Trick hat to show point when possible.

C2 M68 Y100 K0 #ec732e	C68 M12 Y93 K1 #64a553	C5 M1 Y91 K0 #fae848	C63 M27 Y18 K0 #669db9/ #487287
C3 M26 Y68 K0 #f3be70	C0 M68 Y33 K0 #f27885/ #c25479	C77 M28 Y1 K0 #2997ce	C77 M47 Y33 K0 #653333
C16 M56 Y90 K2 #cd7f41	C20 M83 Y32 K1 #e9f2f9	C20 M83 Y32 K1 #c25479	C16 M56 Y90 K2
	C7 M2 Y1 K0		

chin is visible when jaw opens

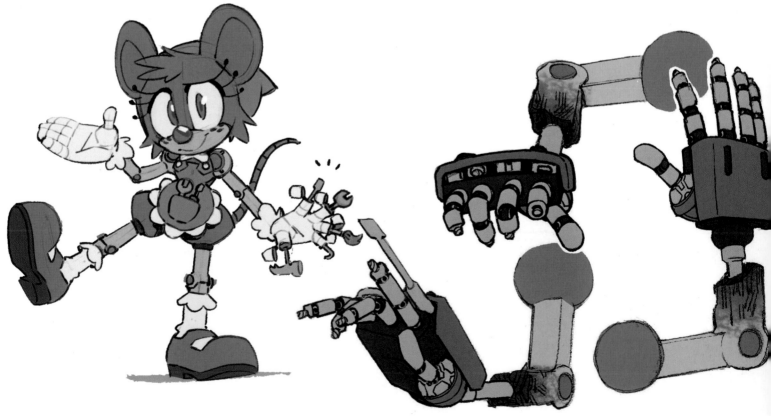

BELLE CHARACTER DESIGNS
AND CONCEPTS BY **EVAN STANLEY**

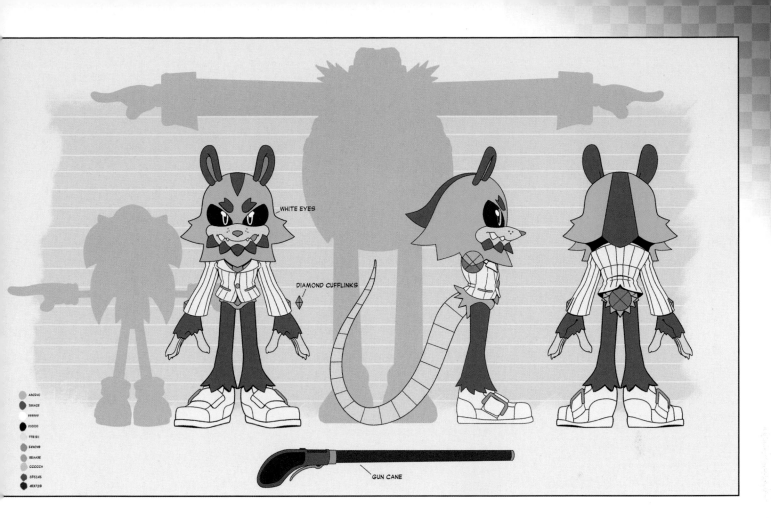

WHITE EYES

DIAMOND CUFFLINKS

GUN CANE

Color swatches:
- A8CD40
- 586A2E
- FFFFFF
- 000000
- FFE1E1
- E49C9B
- EEAA3E
- CCCCCA
- 8F6146
- 4B372B

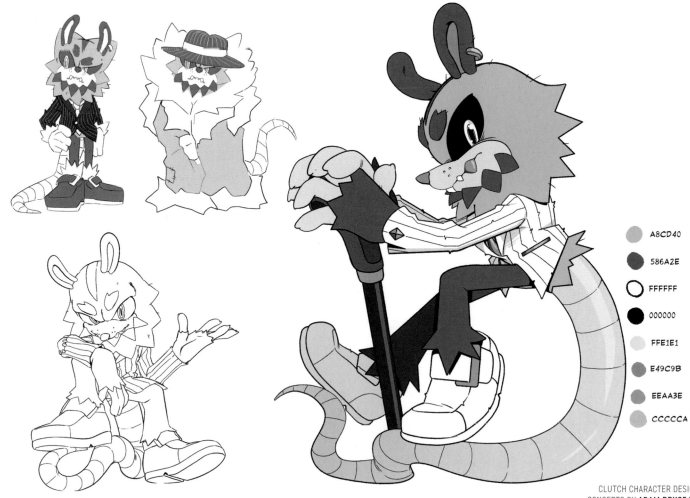

Color swatches:
- A8CD40
- 586A2E
- FFFFFF
- 000000
- FFE1E1
- E49C9B
- EEAA3E
- CCCCCA

CLUTCH CHARACTER DESIGNS AND
CONCEPTS BY **ADAM BRYCE THOMAS**

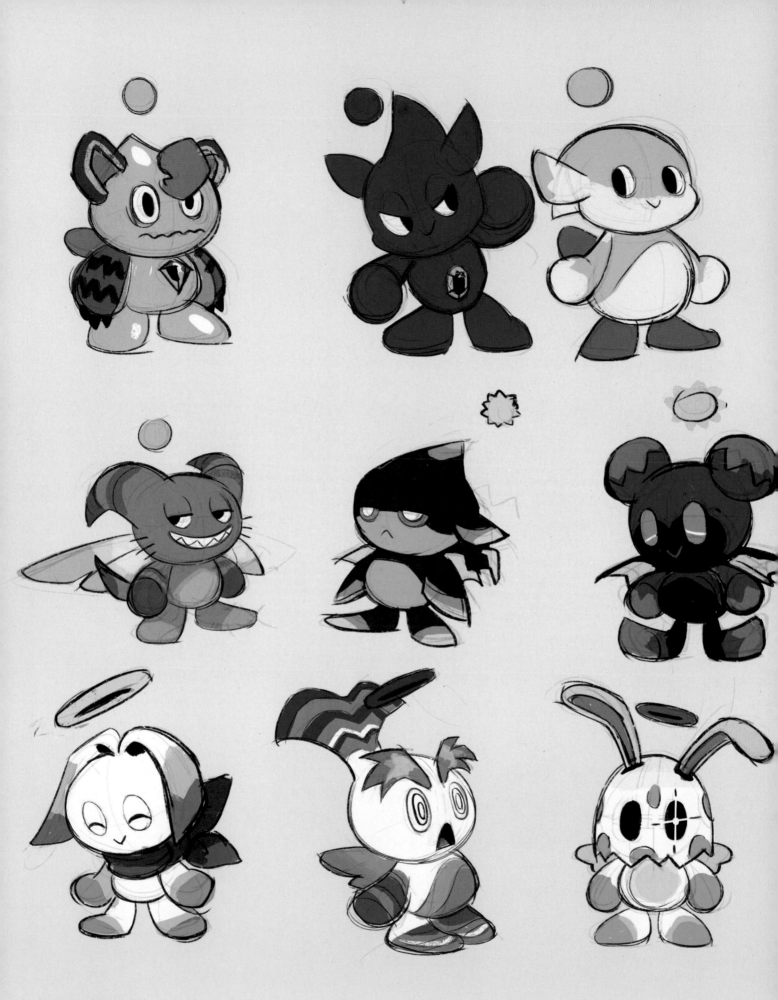

CHAO DESIGNS AND CONCEPTS BY
NATHALIE FOURDRAINE

THE CHAO WERE INITIALLY FEATURED
ON FOURDRAINE'S RI COVER FOR
ISSUE #33, BUT WERE LATER
INCLUDED IN STORY FOR ISSUE #36.
ART BY EVAN STANLEY
COLORS BY REGGIE GRAHAM

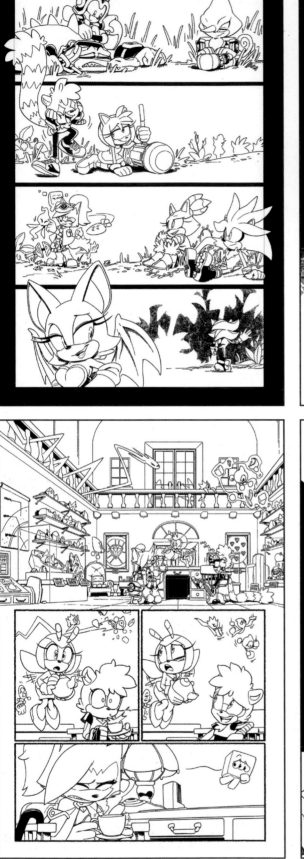

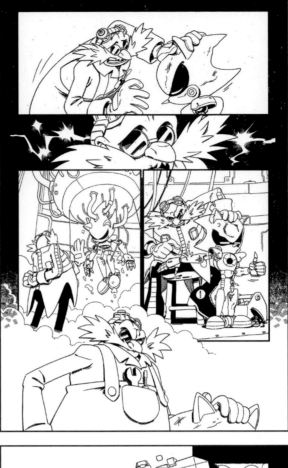

EVAN STANLEY JOINED THE BOOK WITH PENCIL AND INKING DUTIES ON ISSUE #4, ULTIMATELY TAKING OVER WRITING DUTIES ON THE SERIES AS WELL AS ART DUTIES. ENJOY A SELECTION OF HER AND OUR FAVORITE PIECES.

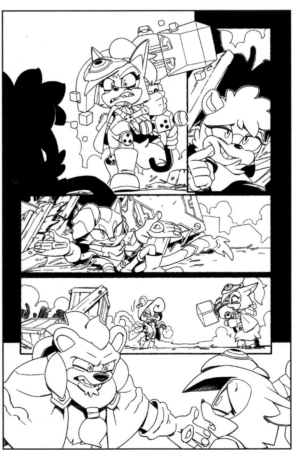

TOP LEFT
SONIC THE HEDGEHOG #11
PAGE 19
PENCILS & INKS

TOP RIGHT
SONIC THE HEDGEHOG #12
PAGE 6
PENCILS & INKS

BOTTOM LEFT
**SONIC THE HEDGEHOG:
TANGLE & WHISPER #1**
PAGE 14
PENCILS & INKS

BOTTOM RIGHT
**SONIC THE HEDGEHOG:
TANGLE & WHISPER #2**
PAGE 13
PENCILS & INKS

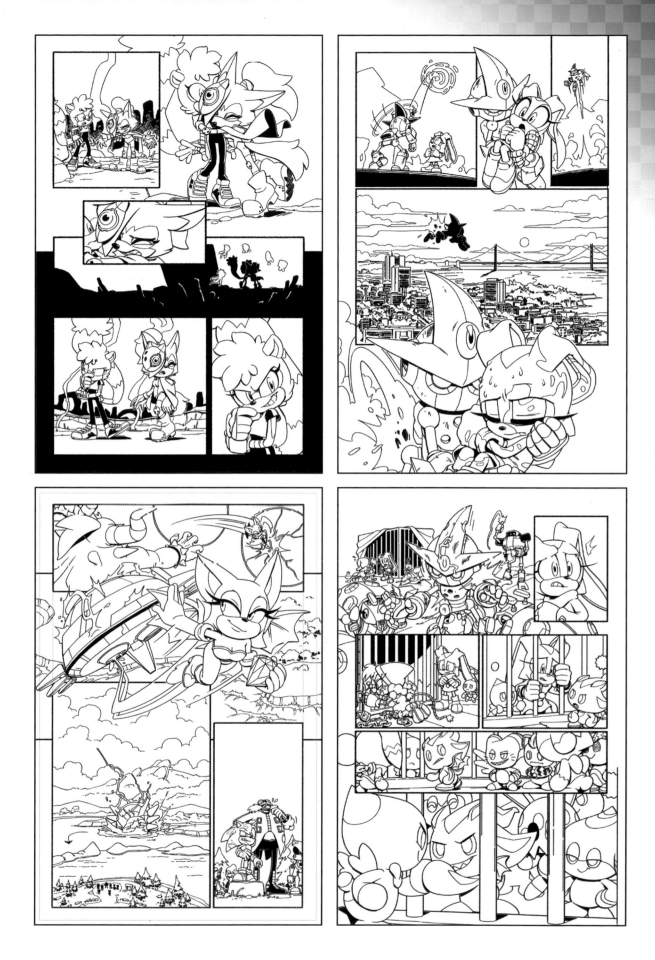

TOP LEFT
SONIC THE HEDGEHOG: TANGLE & WHISPER #3
PAGE 17
PENCILS & INKS

TOP RIGHT
SONIC THE HEDGEHOG #27
PAGE 19
PENCILS & INKS

BOTTOM LEFT
SONIC THE HEDGEHOG #28
PAGE 16
PENCILS & INKS

BOTTOM RIGHT
SONIC THE HEDGEHOG #36
PAGE 6
PENCILS & INKS

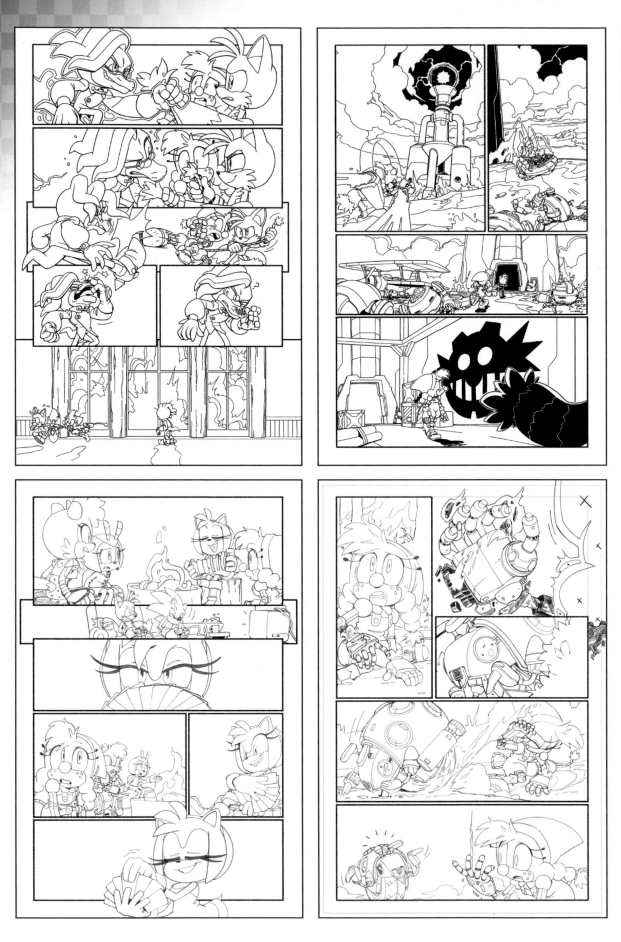

TOP LEFT
SONIC THE HEDGEHOG #36
PAGE 14
PENCILS & INKS

TOP RIGHT
SONIC THE HEDGEHOG #38
PAGE 5
PENCILS & INKS

BOTTOM LEFT
SONIC THE HEDGEHOG #45
PAGE 10
PENCILS

BOTTOM RIGHT
SONIC THE HEDGEHOG #46
PAGE 2
PENCILS

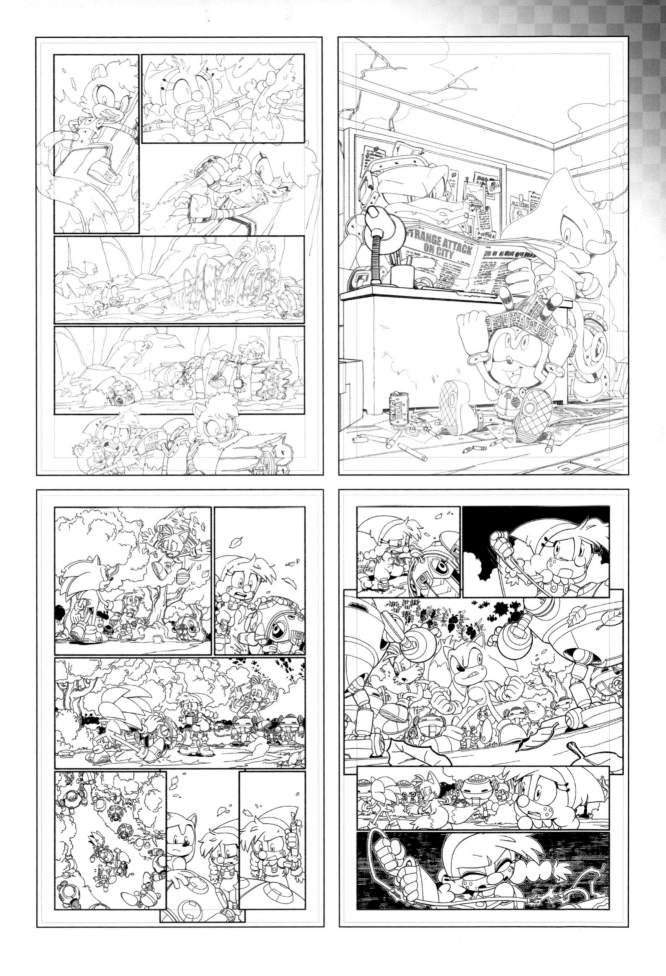

TOP LEFT
SONIC THE HEDGEHOG #47
PAGE 2
PENCILS

TOP RIGHT
SONIC THE HEDGEHOG #47
PAGE 20
PENCILS

BOTTOM LEFT
SONIC THE HEDGEHOG #49
PAGE 14
PENCILS & INKS

BOTTOM RIGHT
SONIC THE HEDGEHOG #49
PAGE 15
PENCILS & INKS

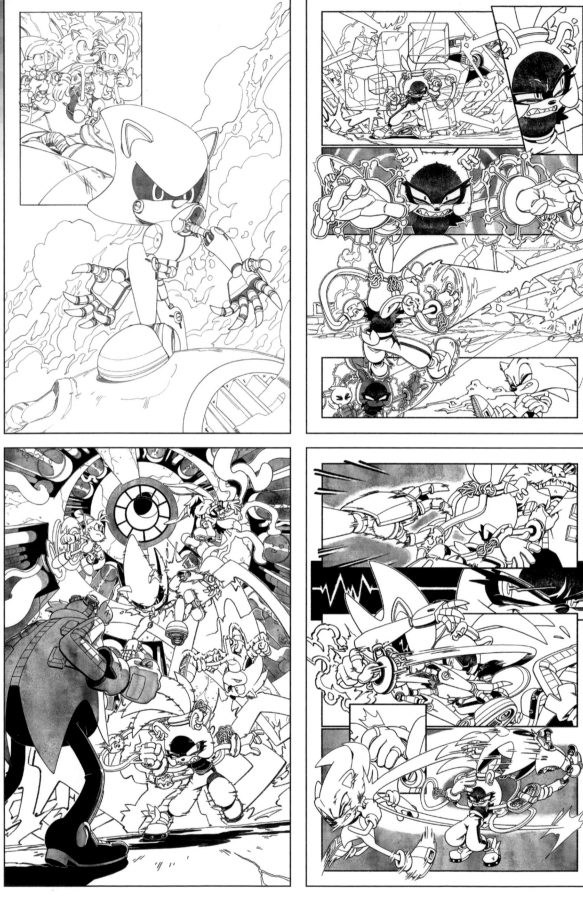

TOP LEFT
SONIC THE HEDGEHOG #52
PAGE 1
PENCILS

TOP RIGHT
SONIC THE HEDGEHOG #54
PAGE 5
PENCILS & INKS

BOTTOM LEFT
SONIC THE HEDGEHOG #56
PAGE 1
PENCILS & INKS

BOTTOM RIGHT
SONIC THE HEDGEHOG #56
PAGE 4
PENCILS & INKS

Statue Savior

The Master

Chao's Fruit

TOP LEFT
AMY'S FORTUNE CARD BACKS
DESIGNED BY **DIANA SKELLY**

TOP RIGHT AND BOTTOM
AMY'S FORTUNE CARD FRONTS
DESIGNED BY **EVAN STANLEY**

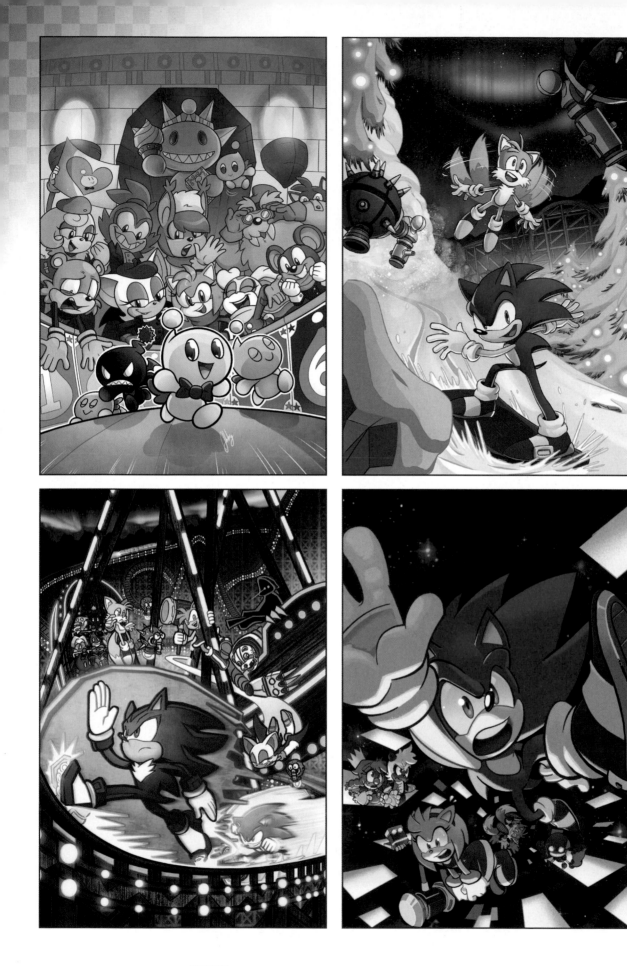

TOP LEFT
SONIC THE HEDGEHOG #34
COVER A
ART BY **ABBY BULMER**

TOP RIGHT
SONIC THE HEDGEHOG #36
COVER A
ART BY **DAN SCHOENING**
COLORS BY **LUIS ANTONIO DELGADO**

BOTTOM LEFT
SONIC THE HEDGEHOG #36
COVER B
ART BY **REGGIE GRAHAM**

BOTTOM RIGHT
SONIC THE HEDGEHOG #38
COVER A
ART BY **MATT HERMS**

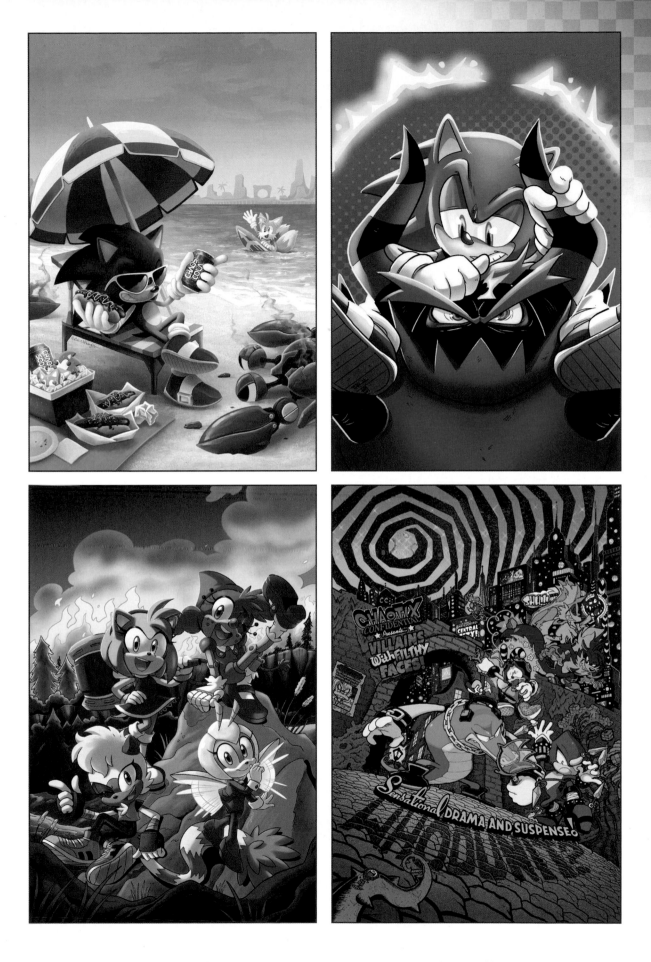

TOP LEFT
SONIC THE HEDGEHOG #41
COVER B
ART BY **NATALIE HAINES**

TOP RIGHT
SONIC THE HEDGEHOG #43
COVER A
ART BY **THOMAS ROTHLISBERGER**
COLORS BY **VALENTINA PINTO**

BOTTOM LEFT
SONIC THE HEDGEHOG #46
COVER A
ART BY **JENNIFER HERNANDEZ**

BOTTOM RIGHT
SONIC THE HEDGEHOG #48
COVER A
ART BY **JONATHAN GRAY**
COLORS BY **REGGIE GRAHAM**

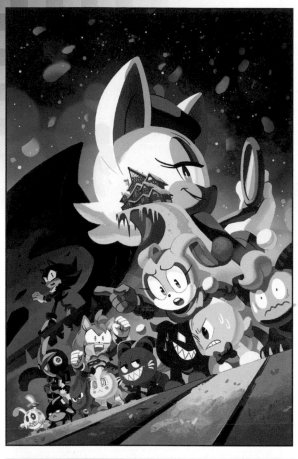

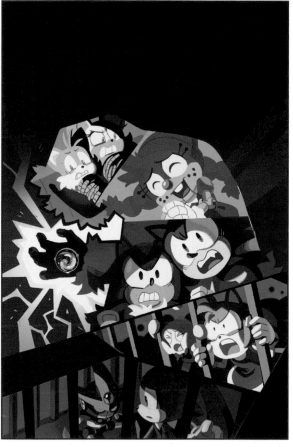

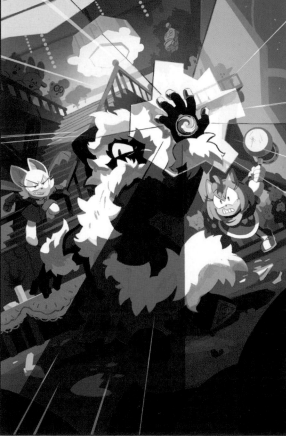

TOP LEFT
SONIC THE HEDGEHOG #33
INCENTIVE COVER
ART BY **NATHALIE FOURDRAINE**

TOP RIGHT
SONIC THE HEDGEHOG #34
INCENTIVE COVER
ART BY **NATHALIE FOURDRAINE**

BOTTOM LEFT
SONIC THE HEDGEHOG #35
INCENTIVE COVER
ART BY **NATHALIE FOURDRAINE**

BOTTOM RIGHT
SONIC THE HEDGEHOG #36
INCENTIVE COVER
ART BY **NATHALIE FOURDRAINE**

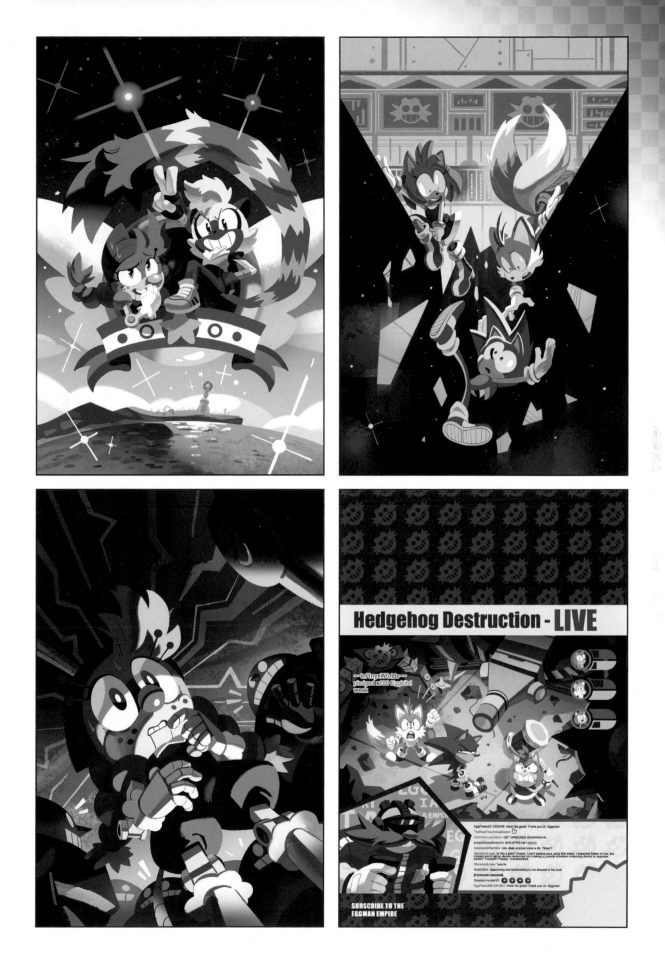

TOP LEFT
SONIC THE HEDGEHOG #37
INCENTIVE COVER
ART BY **NATHALIE FOURDRAINE**

TOP RIGHT
SONIC THE HEDGEHOG #38
INCENTIVE COVER
ART BY **NATHALIE FOURDRAINE**

BOTTOM LEFT
SONIC THE HEDGEHOG #39
INCENTIVE COVER
ART BY **NATHALIE FOURDRAINE**

BOTTOM RIGHT
SONIC THE HEDGEHOG #40
INCENTIVE COVER
ART BY **NATHALIE FOURDRAINE**

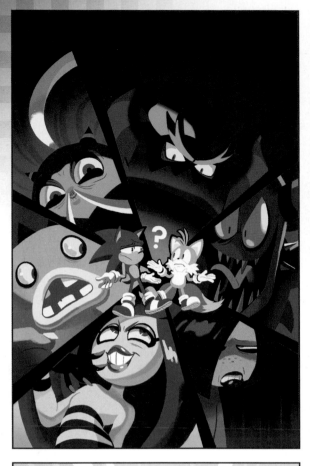

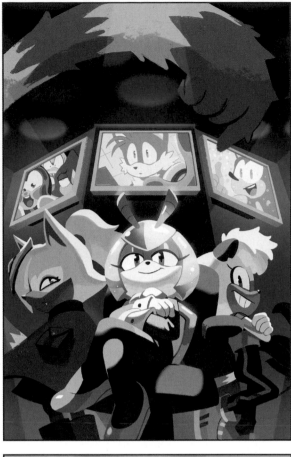

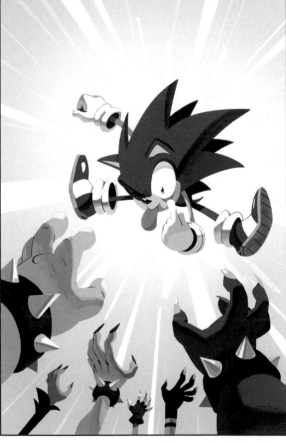

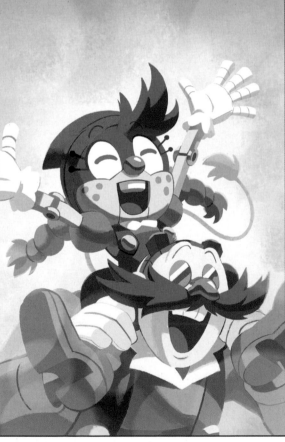

TOP LEFT
SONIC THE HEDGEHOG #41
INCENTIVE COVER
ART BY **NATHALIE FOURDRAINE**

TOP RIGHT
SONIC THE HEDGEHOG #42
INCENTIVE COVER
ART BY **NATHALIE FOURDRAINE**

BOTTOM LEFT
SONIC THE HEDGEHOG #43
INCENTIVE COVER
ART BY **NATHALIE FOURDRAINE**

BOTTOM RIGHT
SONIC THE HEDGEHOG #44
INCENTIVE COVER
ART BY **NATHALIE FOURDRAINE**

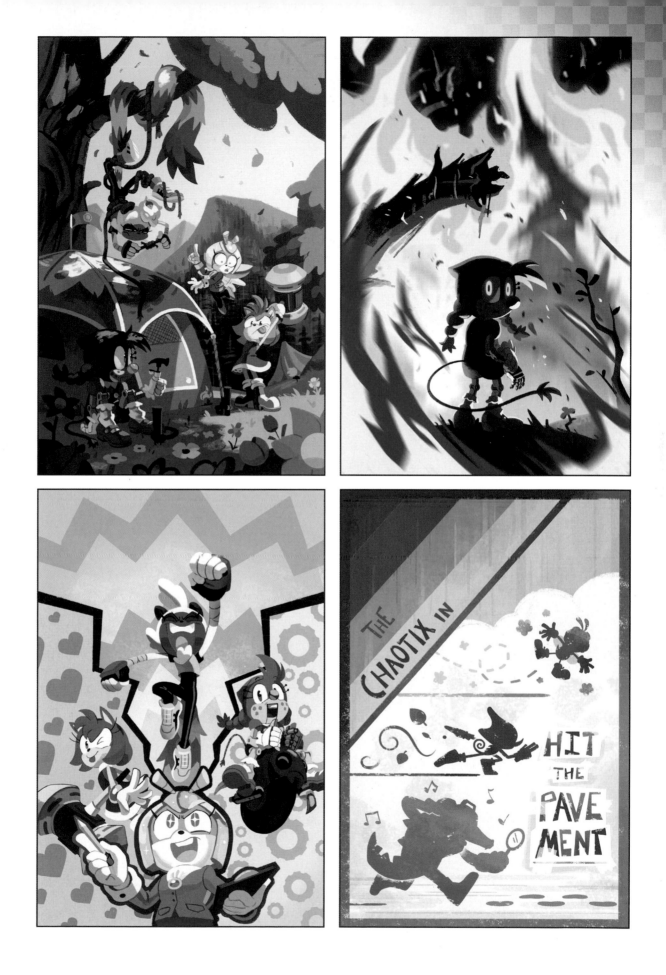

TOP LEFT
SONIC THE HEDGEHOG #45
INCENTIVE COVER
ART BY **NATHALIE FOURDRAINE**

TOP RIGHT
SONIC THE HEDGEHOG #46
INCENTIVE COVER
ART BY **NATHALIE FOURDRAINE**

BOTTOM LEFT
SONIC THE HEDGEHOG #47
INCENTIVE COVER
ART BY **NATHALIE FOURDRAINE**

BOTTOM RIGHT
SONIC THE HEDGEHOG #48
INCENTIVE COVER
ART BY **NATHALIE FOURDRAINE**

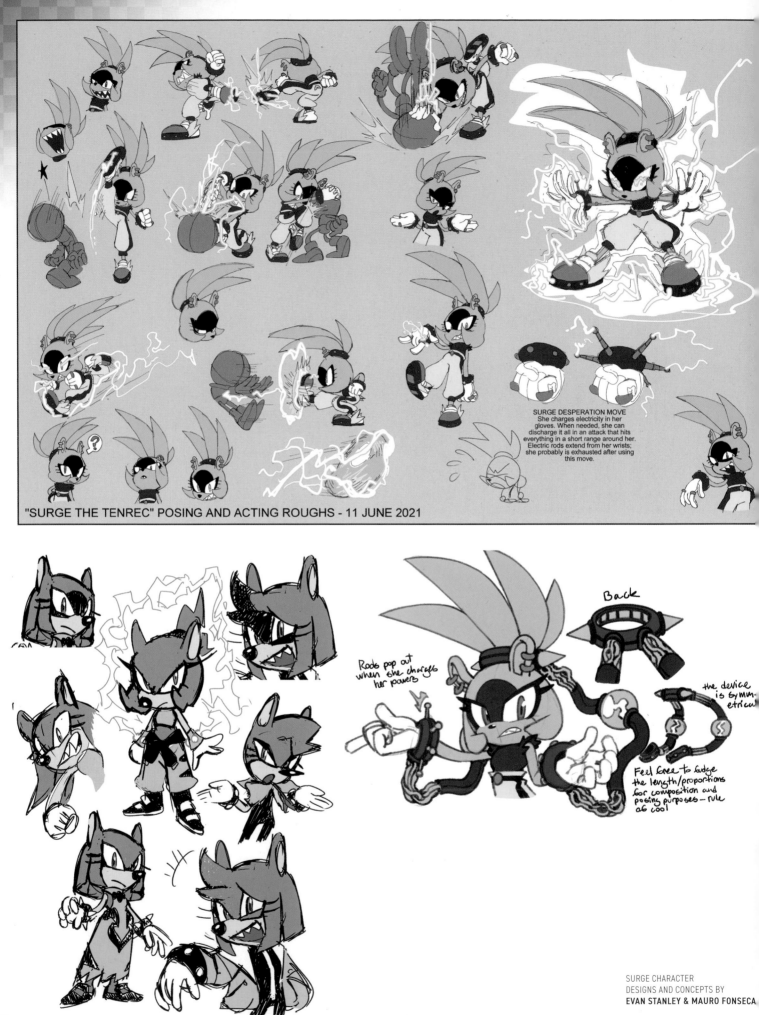

"SURGE THE TENREC" POSING AND ACTING ROUGHS - 11 JUNE 2021

SURGE DESPERATION MOVE
She charges electricity in her gloves. When needed, she can discharge it all in an attack that hits everything in a short range around her. Electric rods extend from her wrists; she probably is exhausted after using this move.

Back

Rods pop out when she charges her powers

the device is symmetrical

Feel free to fudge the length/proportions for composition and posing purposes — rule of cool

SURGE CHARACTER DESIGNS AND CONCEPTS BY
EVAN STANLEY & MAURO FONSECA

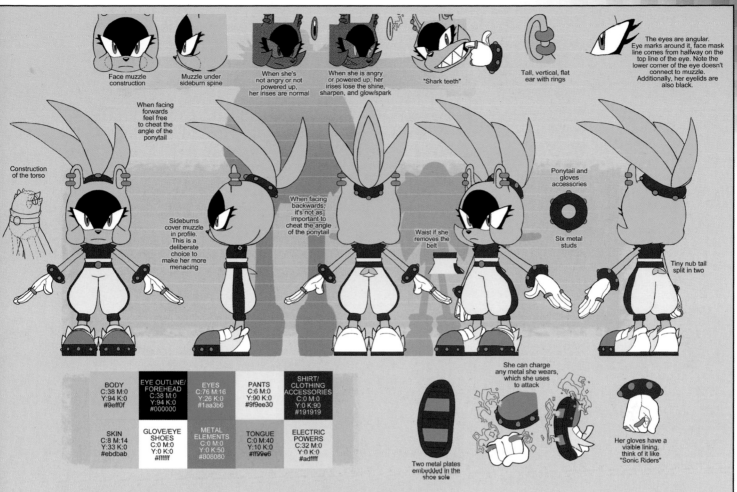

Face muzzle construction

Muzzle under sideburn spine

When she's not angry or not powered up, her irises are normal

When she is angry or powered up, her irises lose the shine, sharpen, and glow/spark

"Shark teeth"

Tall, vertical, flat ear with rings

The eyes are angular. Eye marks around it, face mask line comes from halfway on the top line of the eye. Note the lower corner of the eye doesn't connect to muzzle. Additionally, her eyelids are also black.

Construction of the torso

When facing forwards feel free to cheat the angle of the ponytail

Sideburns cover muzzle in profile. This is a deliberate choice to make her more menacing

When facing backwards, it's not as important to cheat the angle of the ponytail

Waist if she removes the belt

Ponytail and gloves accessories

Six metal studs

Tiny nub tail split in two

BODY C:38 M:0 Y:94 K:0 #9eff0f	EYE OUTLINE/ FOREHEAD C:38 M:0 Y:94 K:0 #000000	EYES C:76 M:16 Y:26 K:0 #1aa3b6	PANTS C:6 M:0 Y:90 K:0 #9f9ee30	SHIRT/ CLOTHING ACCESSORIES C:0 M:0 Y:0 K:90 #191919
SKIN C:8 M:14 Y:33 K:0 #ebdbab	GLOVE/EYE SHOES C:0 M:0 Y:0 K:0 #ffffff	METAL ELEMENTS C:0 M:0 Y:0 K:50 #808080	TONGUE C:0 M:40 Y:10 K:0 #ff99e6	ELECTRIC POWERS C:32 M:0 Y:0 K:0 #adffff

Two metal plates embedded in the shoe sole

She can charge any metal she wears, which she uses to attack

Her gloves have a visible lining, think of it like "Sonic Riders"

"SURGE THE TENREC" TURNAROUND AND DETAILS CONCEPT - 11 JUNE 2021

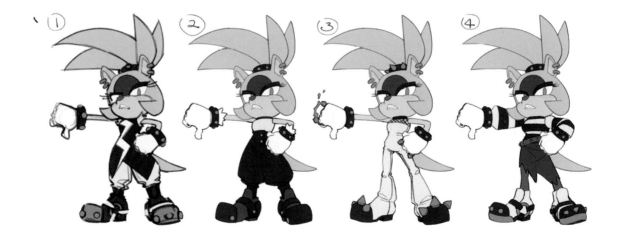

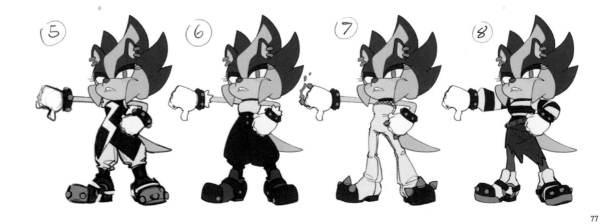

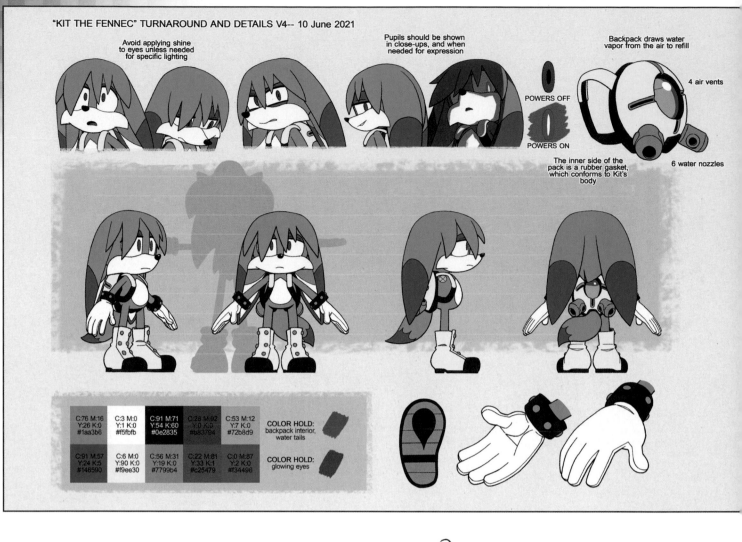

Avoid applying shine to eyes unless needed for specific lighting

Pupils should be shown in close-ups, and when needed for expression

POWERS OFF

POWERS ON

Backpack draws water vapor from the air to refill

4 air vents

6 water nozzles

The inner side of the pack is a rubber gasket, which conforms to Kit's body

C:76 M:16 Y:26 K:0 #1aa3b6	C:3 M:0 Y:1 K:0 #f5fbfb	C:91 M:71 Y:54 K:60 #0e2835	C:28 M:92 Y:0 K:0 #b837f4	C:53 M:12 Y:7 K:0 #72b8d9
C:91 M:57 Y:24 K:5 #146590	C:6 M:0 Y:90 K:0 #f9ee30	C:56 M:31 Y:19 K:0 #7799b4	C:22 M:81 Y:33 K:1 #c25479	C:0 M:87 Y:2 K:0 #f34496

COLOR HOLD: backpack interior, water tails

COLOR HOLD: glowing eyes

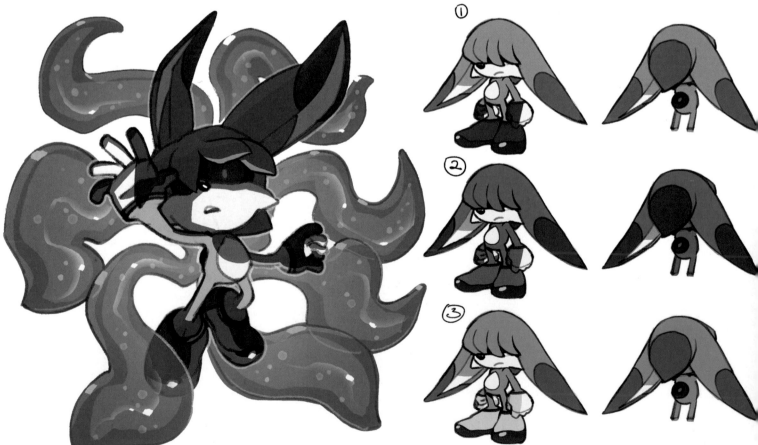

① ② ③

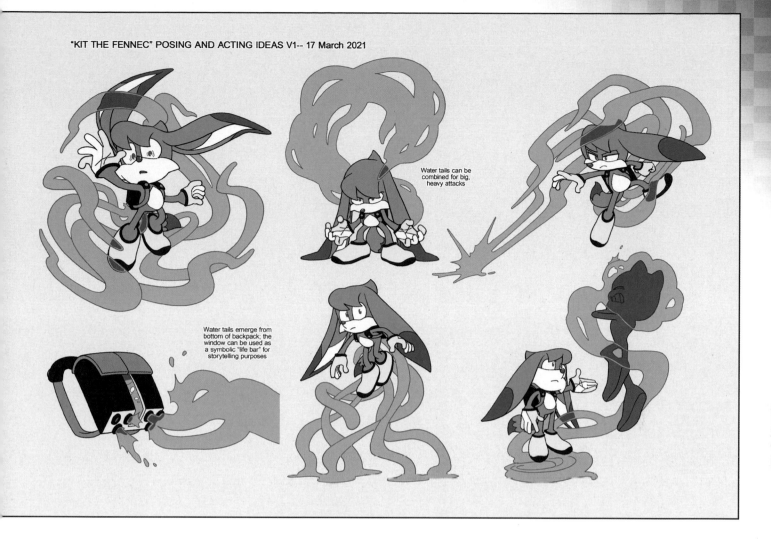

Water tails can be combined for big, heavy attacks

Water tails emerge from bottom of backpack; the window can be used as a symbolic "life bar" for storytelling purposes

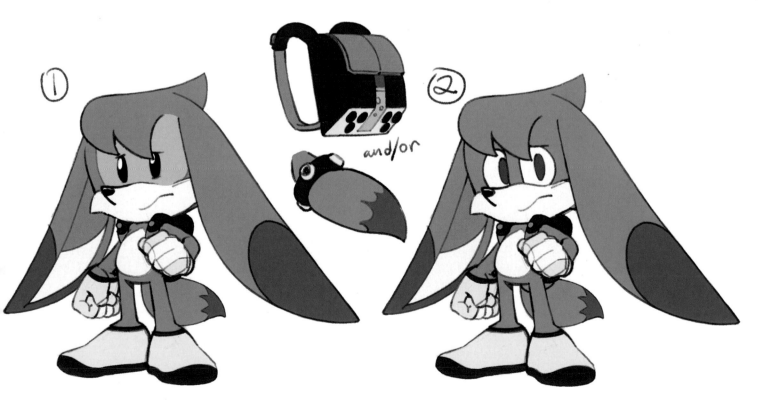

① and/or ②

KIT CHARACTER DESIGNS AND CONCEPTS BY
EVAN STANLEY & MAURO FONSECA

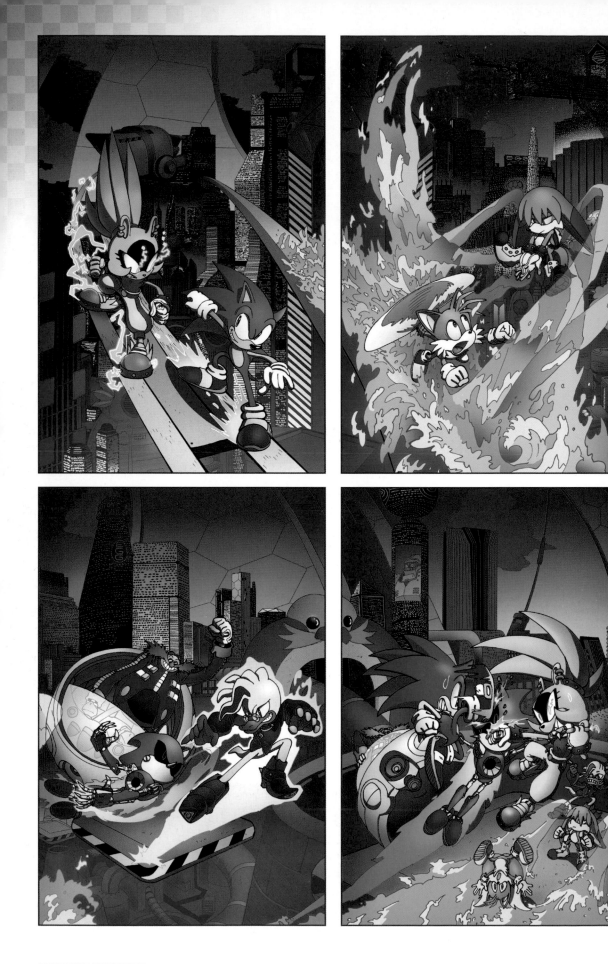

SONIC THE HEDGEHOG:
IMPOSTER SYNDROME #1-4
COVER A CONNECTING
ART BY **MAURO FONSECA**
COLORS BY **JOANA LAFUENTE**

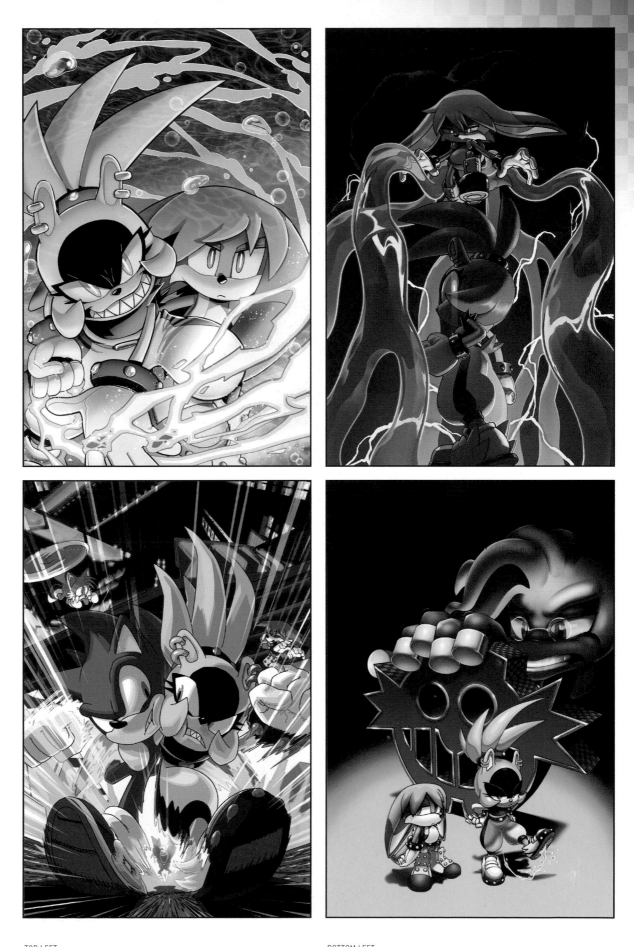

TOP LEFT

**SONIC THE HEDGEHOG:
IMPOSTER SYNDROME #1**
COVER B

ART BY **THOMAS ROTHLISBERGER**
COLORS BY **VALENTINA PINTO**

TOP RIGHT

**SONIC THE HEDGEHOG:
IMPOSTER SYNDROME #1**
INCENTIVE COVER

ART BY **EVAN STANLEY**

BOTTOM LEFT

**SONIC THE HEDGEHOG:
IMPOSTER SYNDROME #1**
EXCLUSIVE COVER

ART BY **BEN BATES**
COLORS BY **MARI TAKEYAMI**

BOTTOM RIGHT

**SONIC THE HEDGEHOG:
IMPOSTER SYNDROME #2**
INCENTIVE COVER

ART BY **ADAM BRYCE THOMAS**

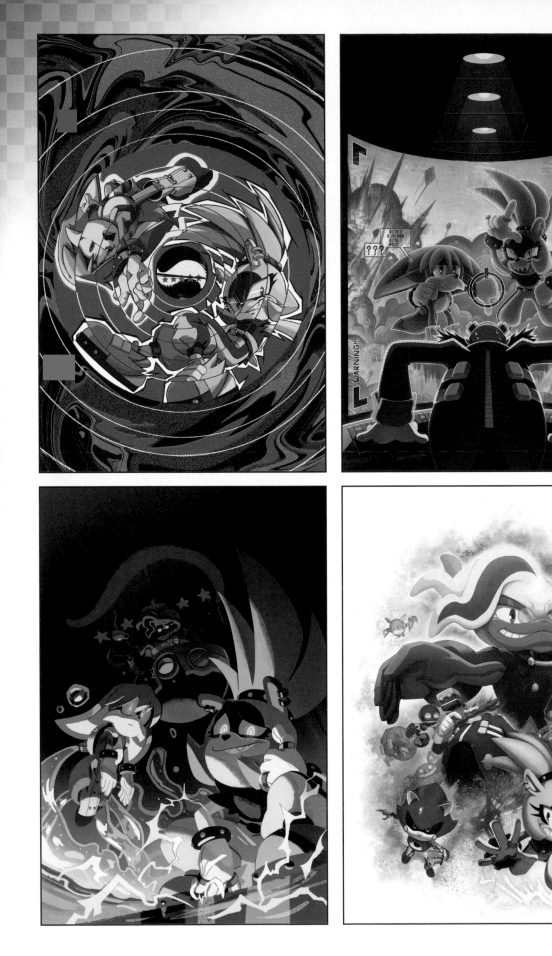

TOP LEFT
**SONIC THE HEDGEHOG:
IMPOSTER SYNDROME #3**
COVER B
ART BY **BRACARDI CURRY**

TOP RIGHT
**SONIC THE HEDGEHOG:
IMPOSTER SYNDROME #4**
COVER B
ART BY **NATALIE HAINES**

BOTTOM LEFT
**SONIC THE HEDGEHOG:
IMPOSTER SYNDROME #4**
INCENTIVE COVER
ART BY **NATHALIE FOURDRAINE**

BOTTOM RIGHT
**SONIC THE HEDGEHOG:
IMPOSTER SYNDROME #4**
EXCLUSIVE COVER
ART BY **GIGI DUTREIX**

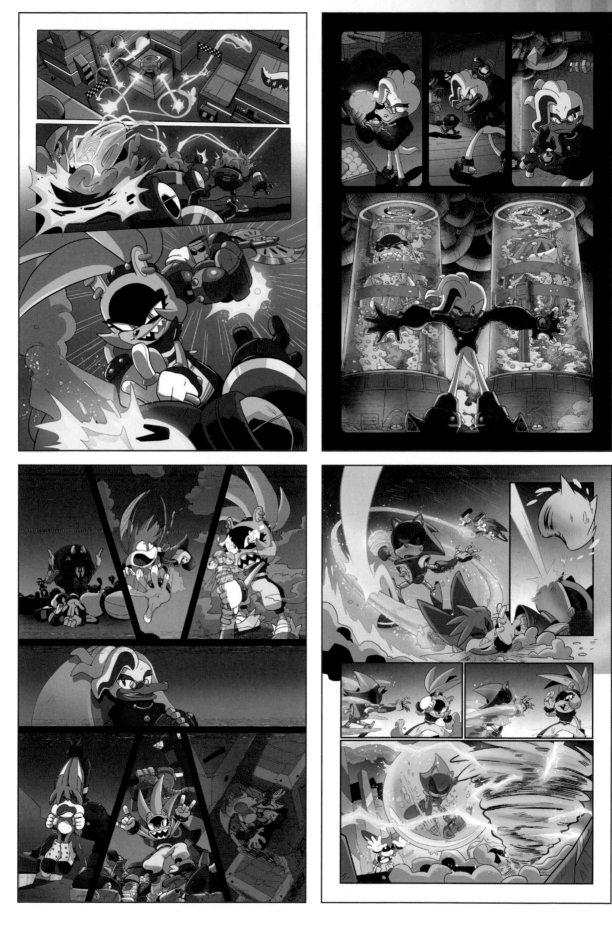

TOP LEFT
**SONIC THE HEDGEHOG:
IMPOSTER SYNDROME #1**
PAGE 3
ART BY **THOMAS ROTHLISBERGER**
COLORS BY **VALENTINA PINTO**

TOP RIGHT
**SONIC THE HEDGEHOG:
IMPOSTER SYNDROME #3**
PAGE 2
ART BY **MAURO FONSECA**
COLORS BY **VALENTINA PINTO**

BOTTOM LEFT
**SONIC THE HEDGEHOG:
IMPOSTER SYNDROME #3**
PAGE 9
ART BY **MAURO FONSECA**
COLORS BY **VALENTINA PINTO**

BOTTOM RIGHT
**SONIC THE HEDGEHOG:
IMPOSTER SYNDROME #4**
PAGE 12
ART BY **THOMAS ROTHLISBERGER**
COLORS BY **VALENTINA PINTO**

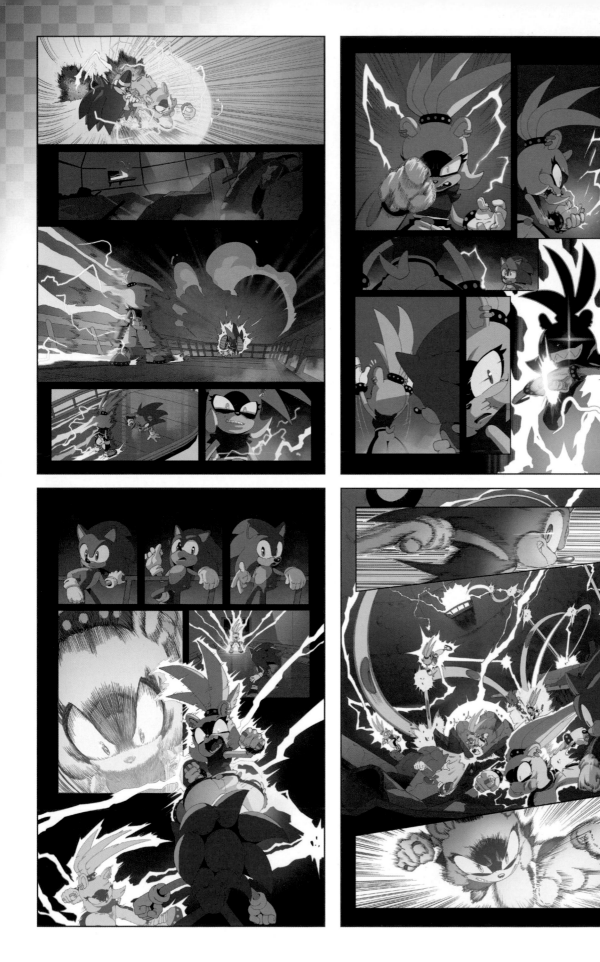

SONIC THE HEDGEHOG #50
PAGES 7-10
ART BY ADAM BRYCE THOMAS
COLORS BY MATT HERMS

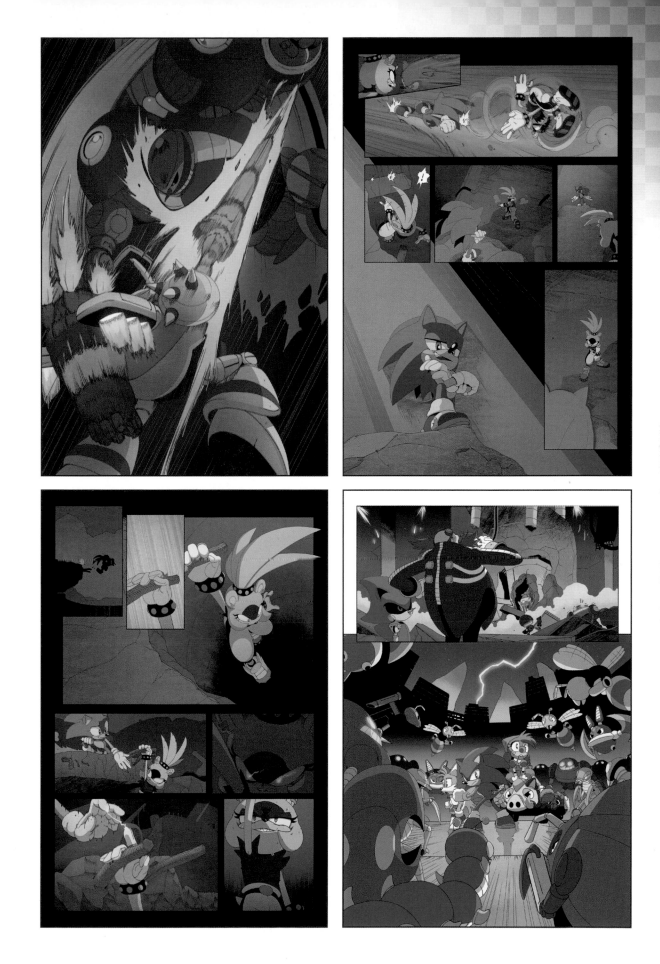

TOP LEFT
SONIC THE HEDGEHOG #50
PAGE 13

ART BY **ADAM BRYCE THOMAS**
COLORS BY **REGGIE GRAHAM**

TOP RIGHT
SONIC THE HEDGEHOG #50
PAGE 24

ART BY **ADAM BRYCE THOMAS**
COLORS BY **MATT HERMS**

BOTTOM LEFT
SONIC THE HEDGEHOG #50
PAGE 38

ART BY **ADAM BRYCE THOMAS**
COLORS BY **MATT HERMS**

BOTTOM RIGHT
SONIC THE HEDGEHOG #50
PAGE 42

ART BY **ADAM BRYCE THOMAS**
COLORS BY **HEATHER BRECKEL**

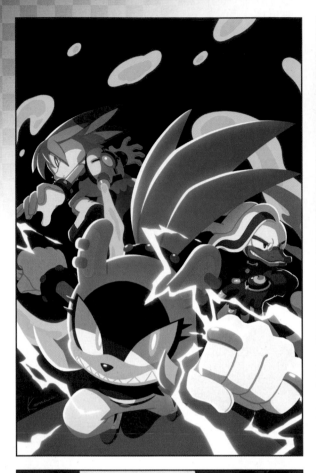

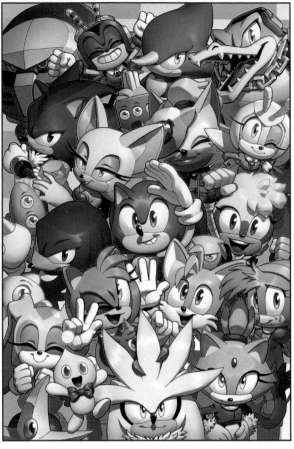

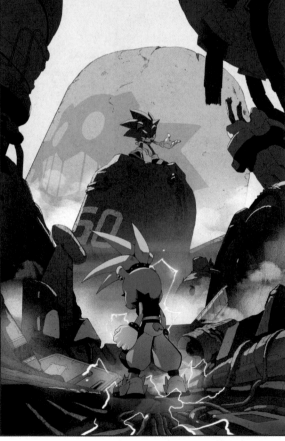

TOP LEFT
SONIC THE HEDGEHOG #50
COVER A
ART BY **YUI KARASUNO** OF SONIC TEAM

TOP RIGHT
SONIC THE HEDGEHOG #50
COVER B
ART BY **EVAN STANLEY**

BOTTOM LEFT
SONIC THE HEDGEHOG #50
COVER C
ART BY **ADAM BRYCE THOMAS**
COLORS BY **MATT HERMS**

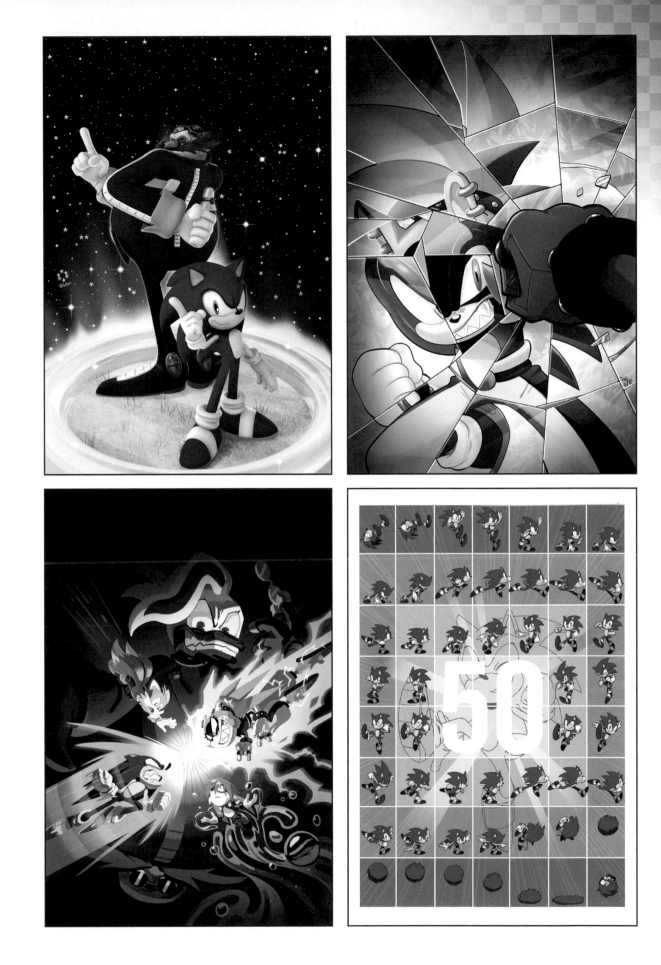

TOP LEFT
SONIC THE HEDGEHOG #50
COVER E
ART BY **NIBROC SARKARIA**

TOP RIGHT
SONIC THE HEDGEHOG #50
COVER F
ART BY **THOMAS ROTHLISBERGER**
COLORS BY **VALENTINA PINTO**

BOTTOM LEFT
SONIC THE HEDGEHOG #50
INCENTIVE COVER
ART BY **NATHALIE FOURDRAINE**

BOTTOM RIGHT
SONIC THE HEDGEHOG #50
INCENTIVE COVER
ART BY **TYSON HESSE**

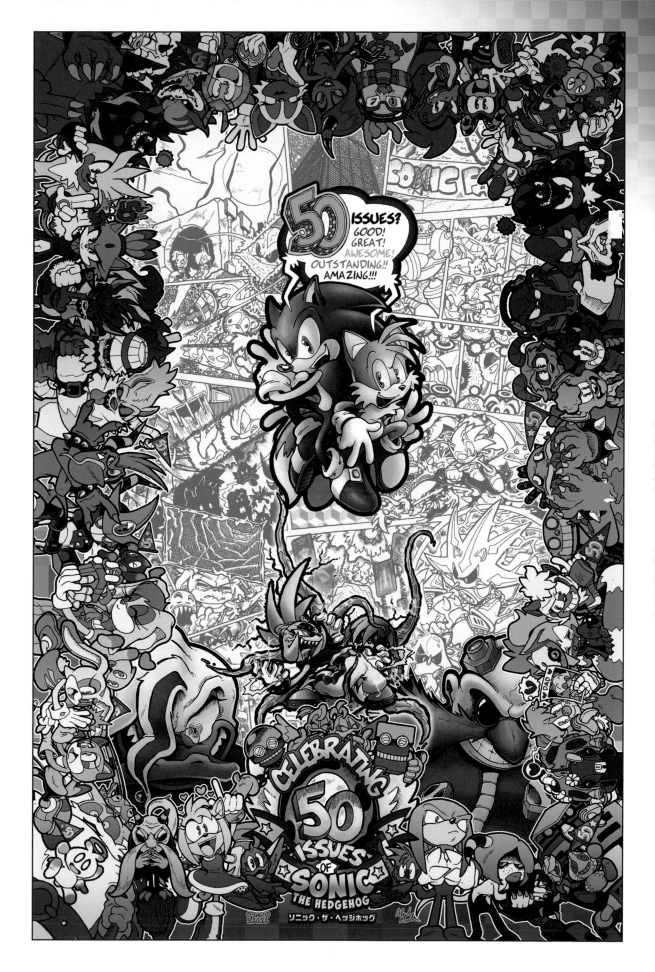

SONIC THE HEDGEHOG #50
COVER D
ART BY JONATHAN GRAY
COLORS BY ALEAH BAKER

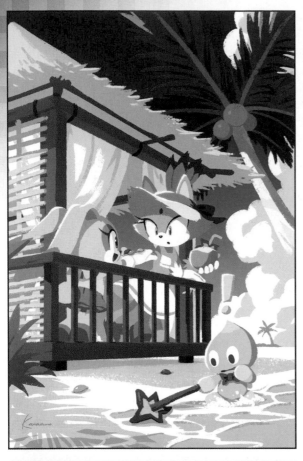

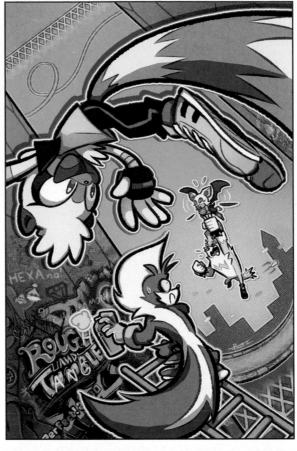

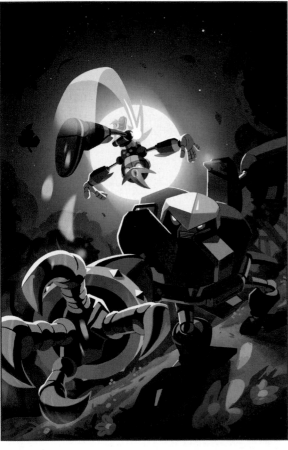

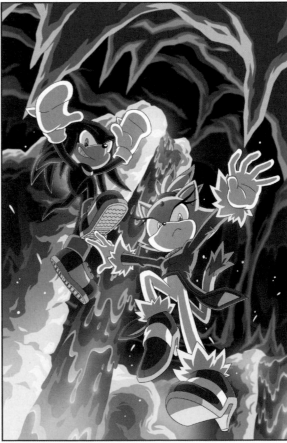

TOP LEFT
SONIC THE HEDGEHOG ANNUAL 2022
COVER A
ART BY **YUI KARASUNO** OF SONIC TEAM

TOP RIGHT
SONIC THE HEDGEHOG ANNUAL 2022
COVER B
ART BY **REGGIE GRAHAM**

BOTTOM LEFT
SONIC THE HEDGEHOG ANNUAL 2022
INCENTIVE COVER
ART BY **NATHALIE FOURDRAINE**

BOTTOM RIGHT
SONIC THE HEDGEHOG ANNUAL 2022
EXCLUSIVE COVER
ART BY **TRACY YARDLEY**

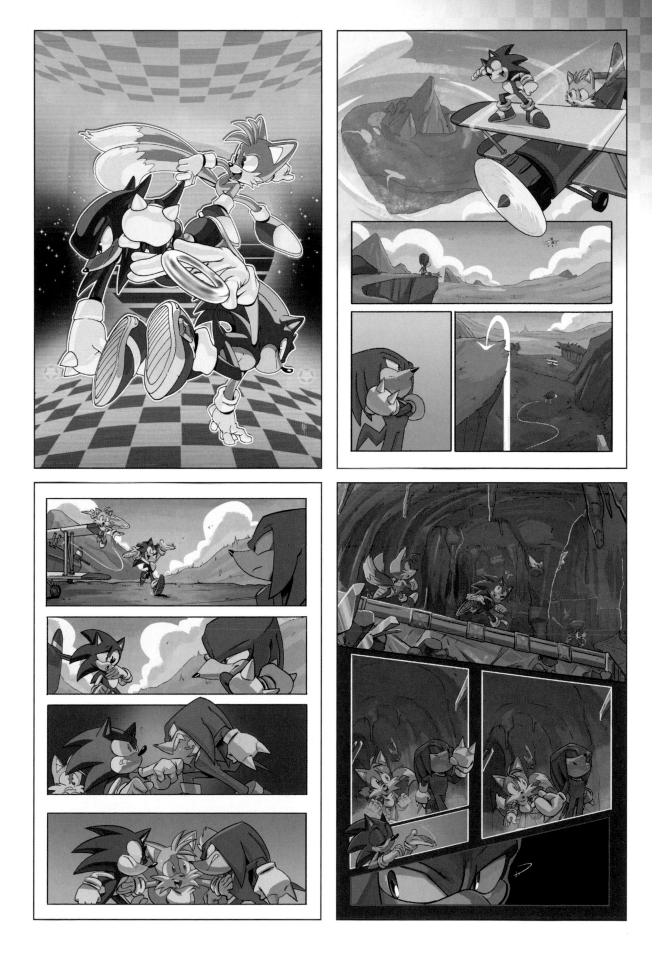

TOP LEFT
SONIC THE HEDGEHOG FREE COMIC BOOK DAY 2022
COVER
ART BY **ADAM BRYCE THOMAS**

TOP RIGHT
SONIC THE HEDGEHOG FREE COMIC BOOK DAY 2022
PAGE 1
ART BY **BRACARDI CURRY**

BOTTOM LEFT
SONIC THE HEDGEHOG FREE COMIC BOOK DAY 2022
PAGE 2
ART BY **BRACARDI CURRY**

BOTTOM RIGHT
SONIC THE HEDGEHOG FREE COMIC BOOK DAY 2022
PAGE 5
ART BY **BRACARDI CURRY**

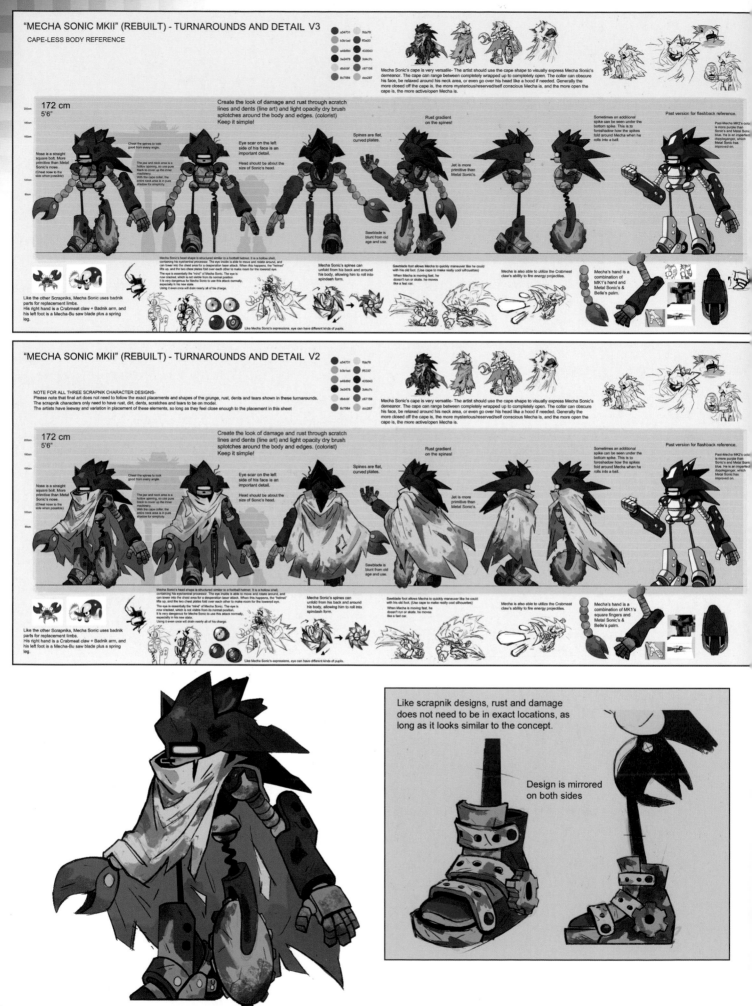

"MECHA SONIC MKII" (REBUILT) - TURNAROUNDS AND DETAIL V3
CAPE-LESS BODY REFERENCE

172 cm
5'6"

Create the look of damage and rust through scratch lines and dents (line art) and light opacity dry brush splotches around the body and edges. (colorist) Keep it simple!

Mecha Sonic's cape is very versatile- The artist should use the cape shape to visually express Mecha Sonic's demeanor. The cape can range between completely wrapped up to completely open. The collar can obscure his face, be relaxed around his neck area, or even go over his head like a hood if needed. Generally the more closed off the cape is, the more mysterious/reserved/self conscious Mecha is, and the more open the cape is, the more active/open Mecha is.

Nose is a straight square bolt. More primitive than Metal Sonic's nose. (Cheat nose to the side when possible!)

Cheat the spines to look good from every angle.

The jaw and neck area is a hollow opening, so use pure black to cover up the inner machinery. With the cape collar, the entire neck area is in pure shadow for simplicity.

Eye scar on the left side of his face is an important detail.

Head should be about the size of Sonic's head.

Spines are flat, curved plates.

Rust gradient on the spines!

Jet is more primitive than Metal Sonic's.

Sawblade foot allows Mecha to quickly maneuver like he could with his old foot.

Sometimes an additional spike can be seen under the bottom spike. This is to foreshadow how the spikes fold around Mecha when he rolls into a ball.

Past version for flashback reference.

Like the other Scrapniks, Mecha Sonic uses badnik parts for replacement limbs. His right hand is a Crabmeat claw + Badnik arm, and his left foot is a Mecha-Bu saw blade plus a spring leg.

Mecha Sonic's head shape is structured similar to a football helmet. It is a hollow shell, containing his eye/central processor. The eye inside is able to move and rotate around, and can lower into the chest area for a desperation laser attack. When this happens, the "helmet" lifts up, and the two chest plates fold over each other to make room for the lowered eye. The eye is essentially the "mind" of Mecha Sonic. The eye is now cracked, which is not visible from its normal position. It is very dangerous for Mecha Sonic to use this attack normally, especially in his new state. Using it even once will drain nearly all of his charge.

Mecha Sonic's spines can unfold from his back and around his body, allowing him to roll into spindash form.

Sawblade foot allows Mecha to quickly maneuver like he could with his old foot. (Use cape to make really cool silhouettes!) When Mecha is moving fast, he doesn't run or skate. He moves like a fast car.

Mecha is also able to utilize the Crabmeat claw's ability to fire energy projectiles.

Mecha's hand is a combination of MK1's hand and Metal Sonic's & Belle's palm.

Like Mecha Sonic's expressions, eye can have different kinds of pupils.

"MECHA SONIC MKII" (REBUILT) - TURNAROUNDS AND DETAIL V2

NOTE FOR ALL THREE SCRAPNIK CHARACTER DESIGNS-
Please note that final art does not need to follow the exact placements and shapes of the grunge, rust, dents and tears shown in these turnarounds. The scrapnik characters only need to have rust, dirt, dents, scratches and tears to be on model. The artists have leeway and variation in placement of these elements, so long as they feel close enough to the placement in this sheet.

Mecha Sonic's cape is very versatile- The artist should use the cape shape to visually express Mecha Sonic's demeanor. The cape can range between completely wrapped up to completely open. The collar can obscure his face, be relaxed around his neck area, or even go over his head like a hood if needed. Generally the more closed off the cape is, the more mysterious/reserved/self conscious Mecha is, and the more open the cape is, the more active/open Mecha is.

172 cm
5'6"

Create the look of damage and rust through scratch lines and dents (line art) and light opacity dry brush splotches around the body and edges. (colorist) Keep it simple!

Nose is a straight square bolt. More primitive than Metal Sonic's nose. (Cheat nose to the side when possible!)

Cheat the spines to look good from every angle.

The jaw and neck area is a hollow opening, so use pure black to cover up the inner machinery. With the cape collar, the entire neck area is in pure shadow for simplicity.

Eye scar on the left side of his face is an important detail.

Head should be about the size of Sonic's head.

Spines are flat, curved plates.

Rust gradient on the spines!

Jet is more primitive than Metal Sonic's.

Sawblade is blunt from old age and use.

Sometimes an additional spike can be seen under the bottom spike. This is to foreshadow how the spikes fold around Mecha when he rolls into a ball.

Past-Mecha MK2's color is more purple than Sonic's and Metal Sonic's blue. He is an imperfect doppelganger, which Metal Sonic has improved on.

Like the other Scrapniks, Mecha Sonic uses badnik parts for replacement limbs. His right hand is a Crabmeat claw + Badnik arm, and his left foot is a Mecha-Bu saw blade plus a spring leg.

Mecha Sonic's head shape is structured similar to a football helmet. It is a hollow shell, containing his eye/central processor. The eye inside is able to move and rotate around, and can lower into the chest area for a desperation laser attack. When this happens, the "helmet" lifts up, and the two chest plates fold over each other to make room for the lowered eye. The eye is essentially the "mind" of Mecha Sonic. The eye is now cracked, which is not visible from its normal position. It is very dangerous for Mecha Sonic to use this attack normally, especially in his new state. Using it even once will drain nearly all of his charge.

Mecha Sonic's spines can unfold from his back and around his body, allowing him to roll into spindash form.

Sawblade foot allows Mecha to quickly maneuver like he could with his old foot. (Use cape to make really cool silhouettes!) When Mecha is moving fast, he doesn't run or skate. He moves like a fast car.

Mecha is also able to utilize the Crabmeat claw's ability to fire energy projectiles.

Mecha's hand is a combination of MK1's square fingers and Metal Sonic's & Belle's palm.

Like Mecha Sonic's expressions, eye can have different kinds of pupils.

Like scrapnik designs, rust and damage does not need to be in exact locations, as long as it looks similar to the concept.

Design is mirrored on both sides

"E-117 SIGMA" TURNAROUND AND DETAIL

Monocle can be played around with for different expressions and moods.

Eyes can be drawn with or without pupils, as well as with or without light shine- It's up to the artist and the mood they want to create.

Expression explorations-
(Note: bottom row expressions are purely for silly, comedic situations and will not be used for general and serious scenes.)

Cheat the wire antenae into charming silhouettes. Should feel stiff, like quirky bent TV antenae.

Sniper scope has been repurposed into a monocle, which doubles as a magnifying glass to help Sigma with repair work

Artist can toggle the monocle on and off to fit the needs of the story.

Egg Robo hand has 4 fingers.

215cm
7'1"

Monocle should feel like a big, wonky eye. Sort of goofy, sort of creepy.

Stylize damage by adding scratch and dent marks through line art. Stylize rust and dirt through using a soft opacity dry brush. Rust and dirt generally accumulate on edges. Keep it simple!

Original arm and legs have two joints instead of one.

Flat tire!

E-Series gun arm is replaced with an Egg-robo arm. Allows Sigma more dexterity to repair machines.
Right foot is a repurposed Anton wheel.

798833	b5e633
4a5186	c1bee7
edb05b	6da8c1
fef8e2	857273
b55328	51b9e3
ddd5b9	803e1d
24273e	bcf6038
385972	406f89

Like most E-series robots, Sigma can transform into vehicle-mode in place of sprinting. He is still slower than the average functioning E-series robot.

He can also tranform into hover-mode. It takes longer for his fan to start now though.

Sigma carries a tool belt in his propellor compartment, which he can open at any time when needed. He uses the fan to rotate through tools.

Like other E-series robots, Sigma can rotate his head 360 degrees.

"MECHA KNUCKLES (REBUILT)" - TURNAROUNDS AND DETAIL

88a8c0	a8964a
ff3434	c58549
d9ca92	d6d2bf
695056	5b2f3a
ddc058	2c313b
753e3e	b98a5c
b03c3d	

Expression Explorations

NOTE FOR ALL THREE SCRAPNIK CHARACTER DESIGNS-
Please note that final art does not need to follow the exact placements and shapes of the grunge, rust, dents and tears shown in these turnarounds.
The scrapnik characters only need to have rust, dirt, dents, scratches and tears to be on model.
The artists have leeway and variation in placement of these elements, so long as they feel close enough to the placement in this sheet

110cm
3'7"
(Same height and body size as Knuckles)

Eye can light up for dramatic effect

Mecha Knuckles missing half of his face is a reference to his defeat in his previous encounter. He uses the cowboy hat to cover up that space.

Eye halftone detail should be drawn in close up shots, but can be removed for mid/far away shots.
Eye can also have a shine gleam if the artist chooses.

Back of hat is scorched.

Hat is tilted towards the missing eye. The solid black creates the illusion of a cool noire shadow.

Cheat the wires and broken metal shapes so they look wild and appealing from every angle.

Dreadlocks and legs have a gradient of rust and dirt.

The interiors of the blown-out sections of the head are a solid black shadow. This is to keep the machinery inside vague and easy to draw.

Fill tread interior with pure black

Like the other scrapniks, Mecha Knuckles reutilizes parts from badniks.
His right foot is a Grounder's tread, and his right and left arms are the tails of a Skorp, with a spike ball for the left hand.
(The spike ball is modified to look more like a spike ball from a Gapsule.)
Mecha Knuckles also wears items original used by Knuckles in past games & media. He wears the SA1 shovel claw on one hand, and wears an old, familiar cowboy hat over his eye.

Mecha Knuckles is still able to fire missiles from his mouth when needed.

With his new arm, Mecha Knuckles can sling his fists around like wrecking balls, and punch from long range.
Arms work similar to Tangle's tail: They can stretch far in action. (However they cannot stretch as far as Tangle's tail.)

Though Mecha Knuckles has 5 arm segments, the artist can increase the amount and lengthen his arms for action poses. (Again, like how Tangle's tail normally only has 7 rings but the number of rings increases when stretched.)

SCRAPNIK MECHA SONIC,
MECHA KNUCKLES, E-117 SIGMA
CHARACTER DESIGNS AND CONCEPTS
NATHALIE FOURDRAINE

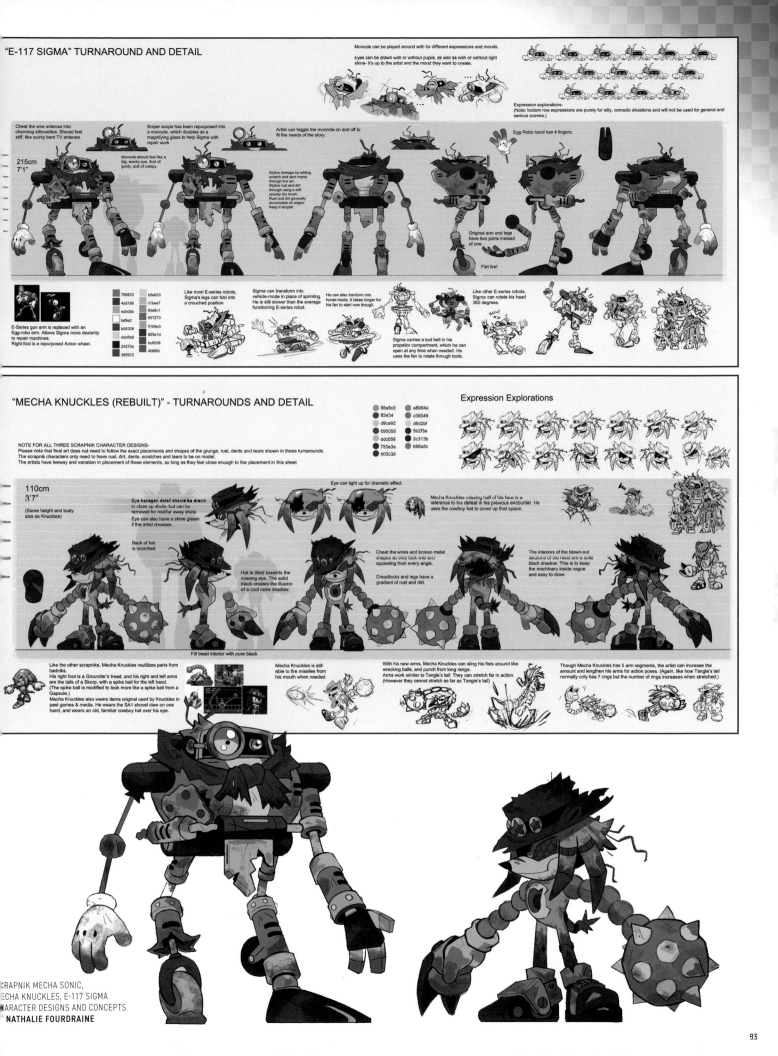

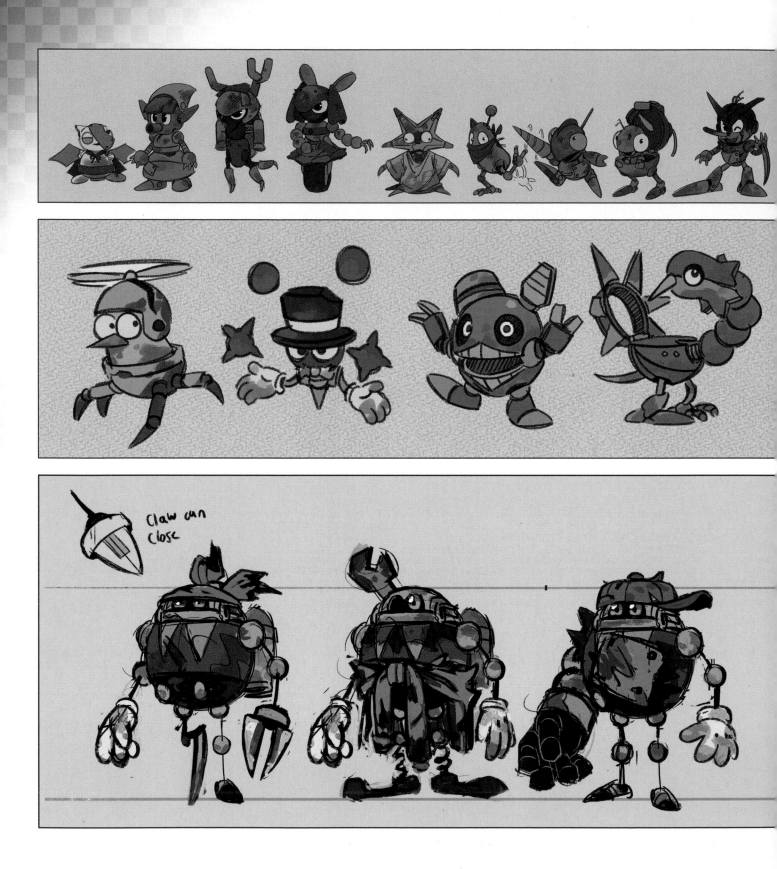

SCRAPNIK ROBOT CHARACTER DESIGNS AND CONCEPTS BY **THOMAS ROTHLISBERGER, MIN HO KIM, NATALIE HAINES, RIK MACK,** AND **NATHALIE FOURDRAINE.**

Claw can close

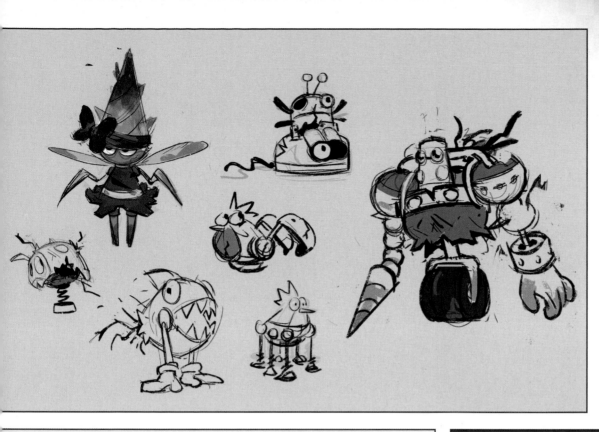

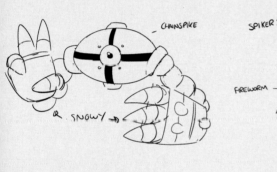

CHAINSPIKE

R. SNOWY →

SPIKER 2

CHAINSPIKE

FIREWORM

— SPLATS

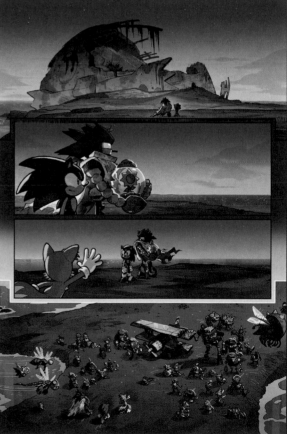

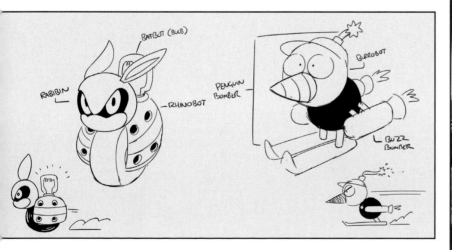

RABIBIN

BATBOT (BUB)

RHINOBOT

BURROBOT

PENGUIN BOMBER

BUZZ BOMBER

MANY OF THESE DESIGNS APPEARED THROUGHOUT THE SERIES, INCLUDING THIS GROUP SHOT ON PAGE 19 OF *SONIC THE HEDGEHOG: SCRAPNIK ISLAND* #4. ART BY **JACK LAWRENCE** COLORS BY **NATHALIE FOURDRAINE**.

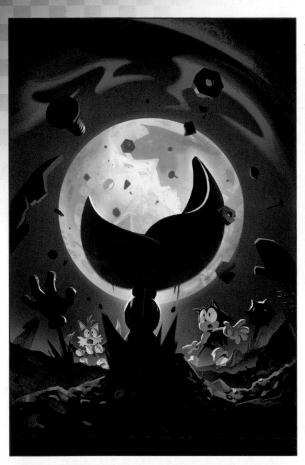
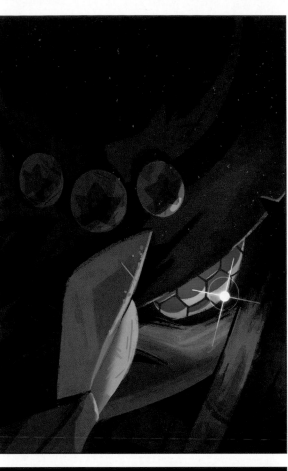
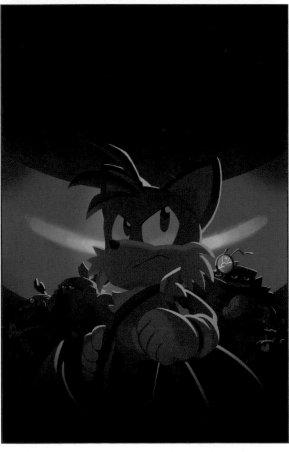
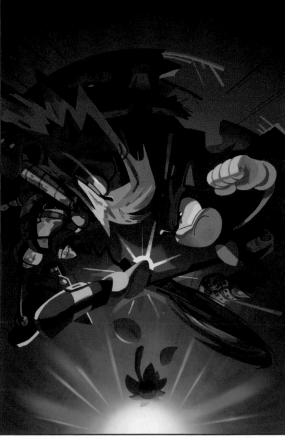

**SONIC THE HEDGEHOG:
SCRAPNIK ISLAND #1-4**
COVER A
ART BY **NATHALIE FOURDRAINE**

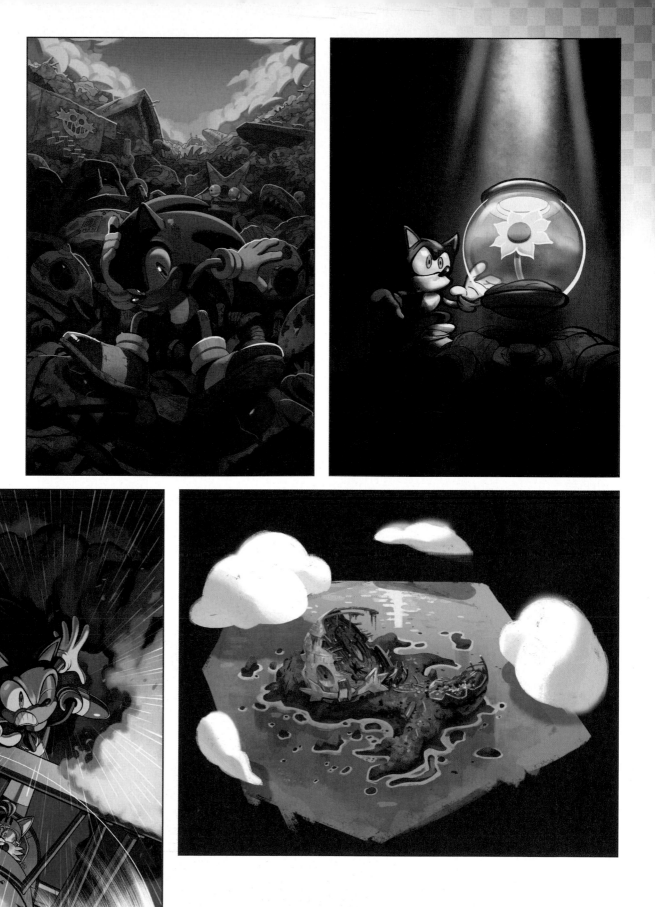

TOP LEFT
SONIC THE HEDGEHOG: SCRAPNIK ISLAND #1
COVER B
ART BY **MIN HO KIM**

TOP RIGHT
SONIC THE HEDGEHOG: SCRAPNIK ISLAND #1
INCENTIVE COVER
ART BY **DIANA SKELLY**

BOTTOM LEFT
SONIC THE HEDGEHOG: SCRAPNIK ISLAND #1
EXCLUSIVE COVER
ART BY **JORDAN GIBSON**

BOTTOM RIGHT
SCRAPNIK ISLAND CONCEPT
ART BY **NATHALIE FOURDRAINE**

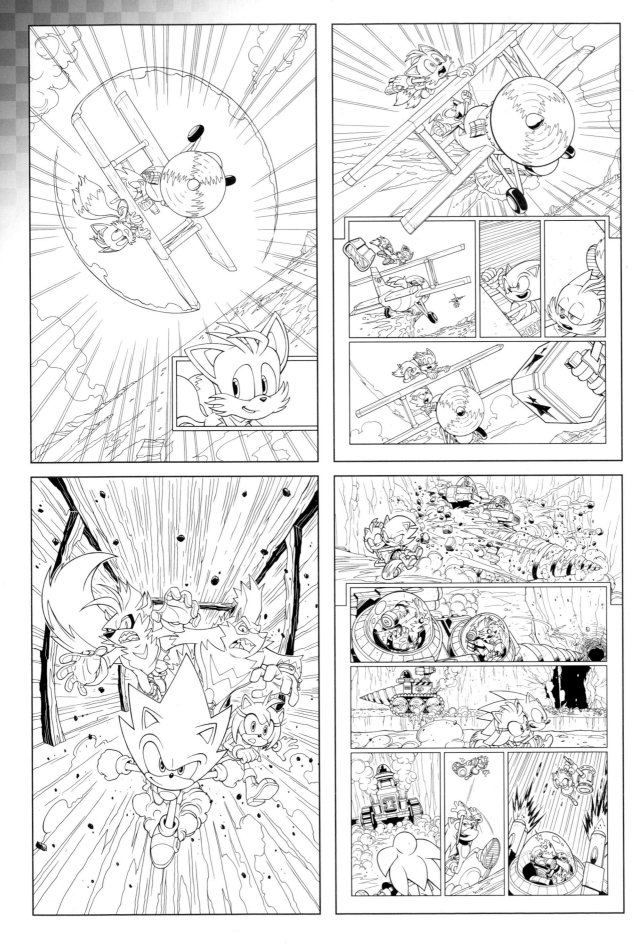

SPOTLIGHT ON ARTIST

JACK LAWRENCE

JACK LAWRENCE JOINED THE
SERIES PENCILING AND INKING THE
"JET SET TORNADO" SHORT IN THE
2019 ANNUAL, AND IN ADDITION TO H
WORK ON THE ONGOING, TOOK THE
LEAD ON THE MINISERIES *BAD GUYS*
AND *SCRAPNIK ISLAND*. ENJOY
A SELECTION OF HIS AND OUR
FAVORITE PIECES.

TOP LEFT
**SONIC THE HEDGEHOG
ANNUAL 2019**
PAGE 13
PENCILS & INKS

TOP RIGHT
**SONIC THE HEDGEHOG
ANNUAL 2019**
PAGE 16
PENCILS & INKS

BOTTOM LEFT
SONIC THE HEDGEHOG #15
COVER A
PENCILS & INKS

BOTTOM RIGHT
SONIC THE HEDGEHOG #15
PAGE 11
PENCILS & INKS

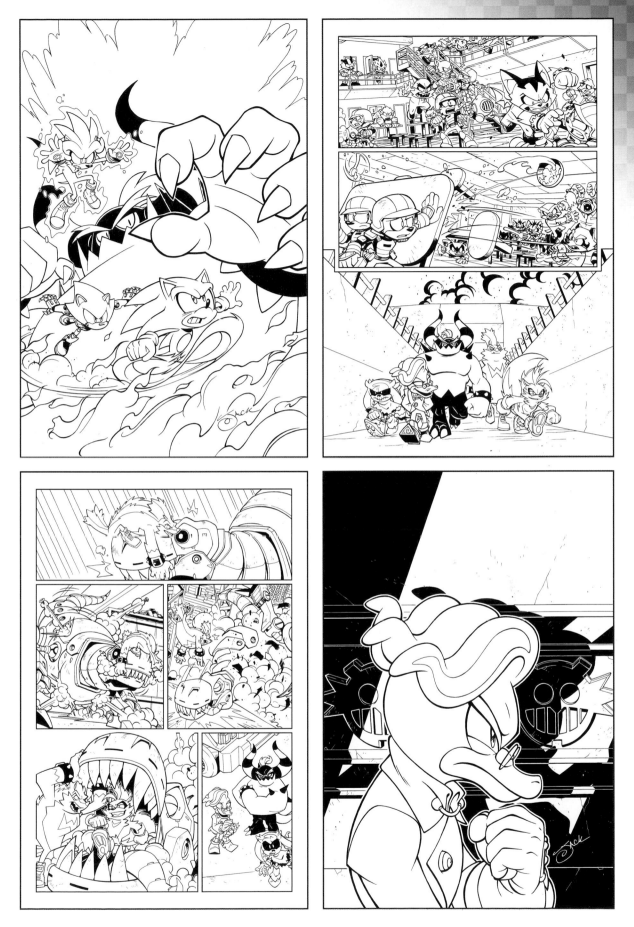

TOP LEFT
SONIC THE HEDGEHOG #29
COVER A
PENCILS & INKS

TOP RIGHT
SONIC THE HEDGEHOG:
BAD GUYS #1
PAGE 20
PENCILS & INKS

BOTTOM LEFT
SONIC THE HEDGEHOG:
BAD GUYS #2
PAGE 15
PENCILS & INKS

BOTTOM RIGHT
SONIC THE HEDGEHOG:
BAD GUYS #3
INCENTIVE COVER
PENCILS & INKS

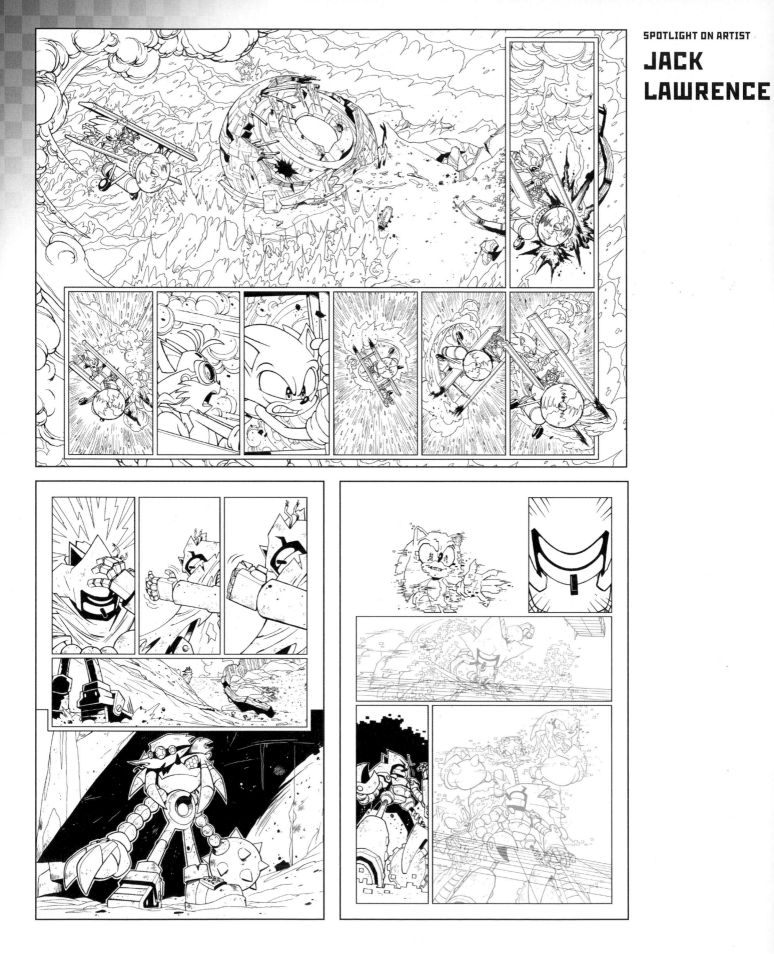

TOP
**SONIC THE HEDGEHOG:
SCRAPNIK ISLAND #1**
PAGES 2–3
PENCILS & INKS

BOTTOM LEFT
**SONIC THE HEDGEHOG:
SCRAPNIK ISLAND #1**
PAGE 20
PENCILS & INKS

BOTTOM RIGHT
**SONIC THE HEDGEHOG:
SCRAPNIK ISLAND #2**
PAGE 17
PENCILS & INKS

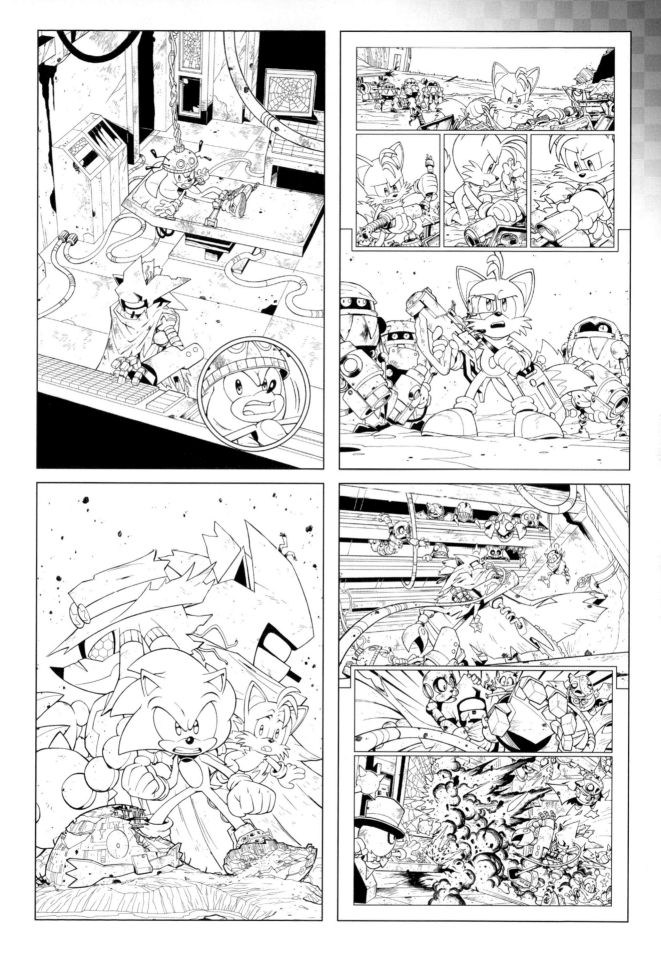

TOP LEFT
SONIC THE HEDGEHOG:
SCRAPNIK ISLAND #3
PAGE 1
PENCILS & INKS

TOP RIGHT
SONIC THE HEDGEHOG:
SCRAPNIK ISLAND #3
PAGE 8
PENCILS & INKS

BOTTOM LEFT
SONIC THE HEDGEHOG:
SCRAPNIK ISLAND #4
INCENTIVE COVER
PENCILS & INKS

BOTTOM RIGHT
SONIC THE HEDGEHOG:
SCRAPNIK ISLAND #4
PAGE 4
PENCILS & INKS

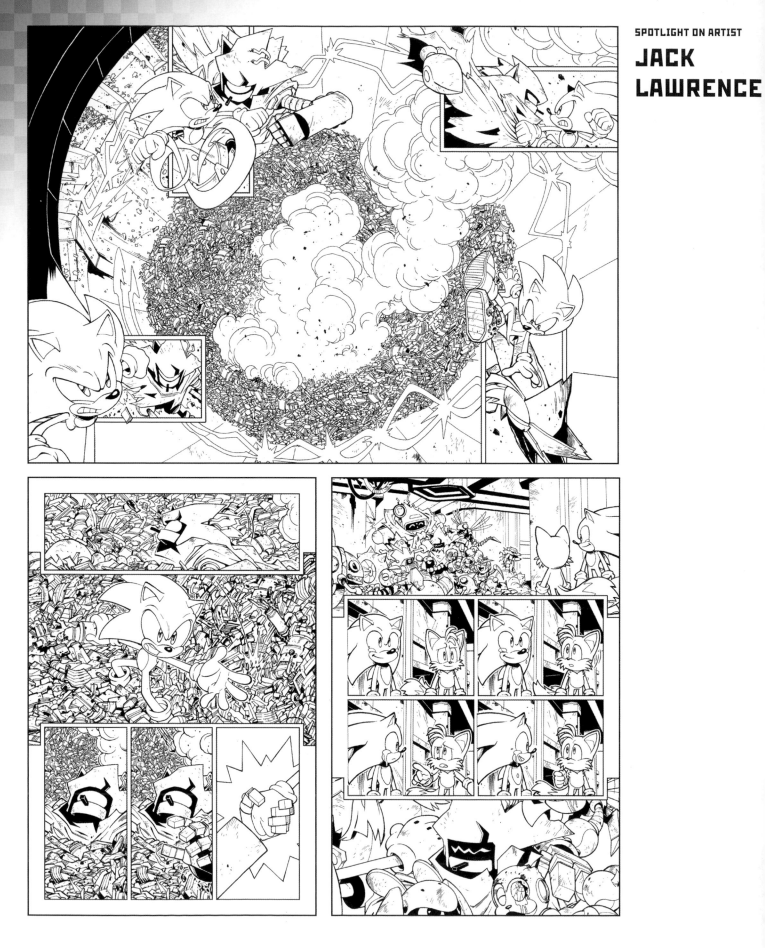

TOP
**SONIC THE HEDGEHOG:
SCRAPNIK ISLAND #4**
PAGES 10-11
PENCILS & INKS

BOTTOM LEFT
**SONIC THE HEDGEHOG:
SCRAPNIK ISLAND #4**
PAGE 14
PENCILS & INKS

BOTTOM RIGHT
**SONIC THE HEDGEHOG:
SCRAPNIK ISLAND #4**
PAGE 17
PENCILS & INKS

LANOLIN:

LANOLIN MET SONIC IN STH#2 AT RIVERSIDE. INSPIRED BY HIS HEROISM, SHE JOINED THE RESTORATION HOPING TO MAKE A DIFFERENCE. HOWEVER, AS THE RESTORATION BEGAN TO FOCUS MORE ON HUMANITARIAN AID SHE GREW FRUSTRATED. SHE FIRMLY BELIEVES THAT A DIRECT APPROACH TO FIGHTING EVIL IS NECESSARY, AND IS TIRED OF WAITING FOR VILLAINS TO STRIKE FIRST. AS A MEMBER OF THE NEW DIAMOND CUTTERS, SHE TAKES HER DUTIES VERY SERIOUSLY AND IS DETERMINED TO PROVE HER WORTH IN BATTLE. SHE MAY COME ACROSS AS COLD AND UNFRIENDLY, BUT DEEP DOWN SHE WANTS TO DO HER BEST FOR THE HEALTH AND SAFETY OF EVERYONE.

PLASTIC EXPRESSION WHEN SMILING

SCLERA IS POWDER BLUE

CLIP CAN OPEN TO RELEASE WISPON

- EXPRESSIONS SHOULD APPEAR WOODEN OR STILTED. EX: DOESN'T SMILE WITH HER EYES.
- WOOL POOFS ARE NOT A STIFF, CONSISTENT SHAPE. RENDER THEM AS NEEDED. HAIR IS BOUNCY WHEN WALKING OR RUNNING.

ZIPPER SLIDER

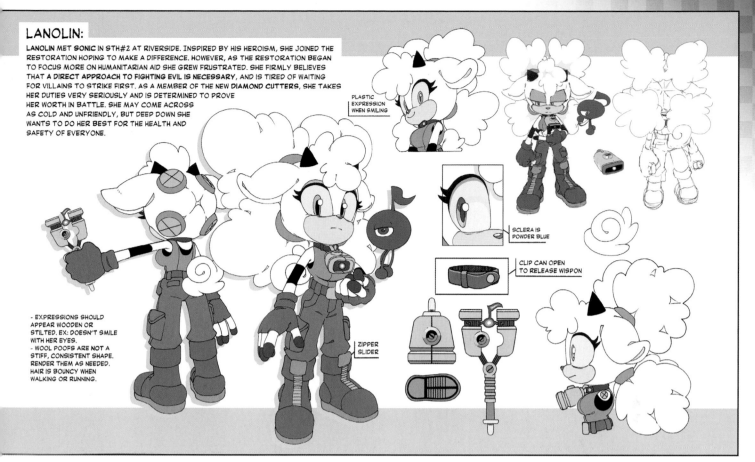

- GOLDEN BELL -

DING DING DING DING

DONG

KLANG KLANG

LANOLIN CHARACTER DESIGNS AND CONCEPTS BY **ADAM BRYCE THOMAS**

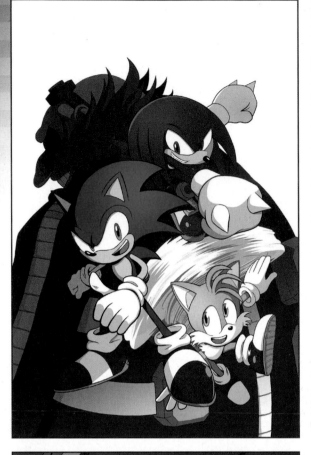

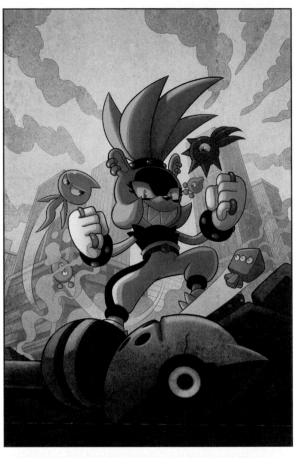

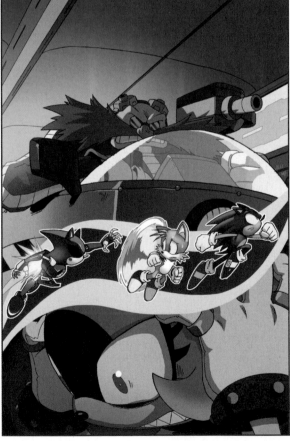

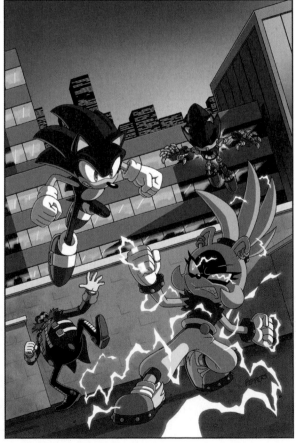

TOP LEFT
SONIC THE HEDGEHOG #51
COVER B
ART BY **ERIC LIDE**

TOP RIGHT
SONIC THE HEDGEHOG #53
COVER B
ART BY **ABBY BALMER**
COLORS BY **REGGIE GRAHAM**

BOTTOM LEFT
SONIC THE HEDGEHOG #55
COVER A
ART BY **AARON HAMMERSTROM**
COLORS BY **MATT HERMS**

BOTTOM RIGHT
SONIC THE HEDGEHOG #56
COVER A
ART BY **JAMAL PEPPERS**

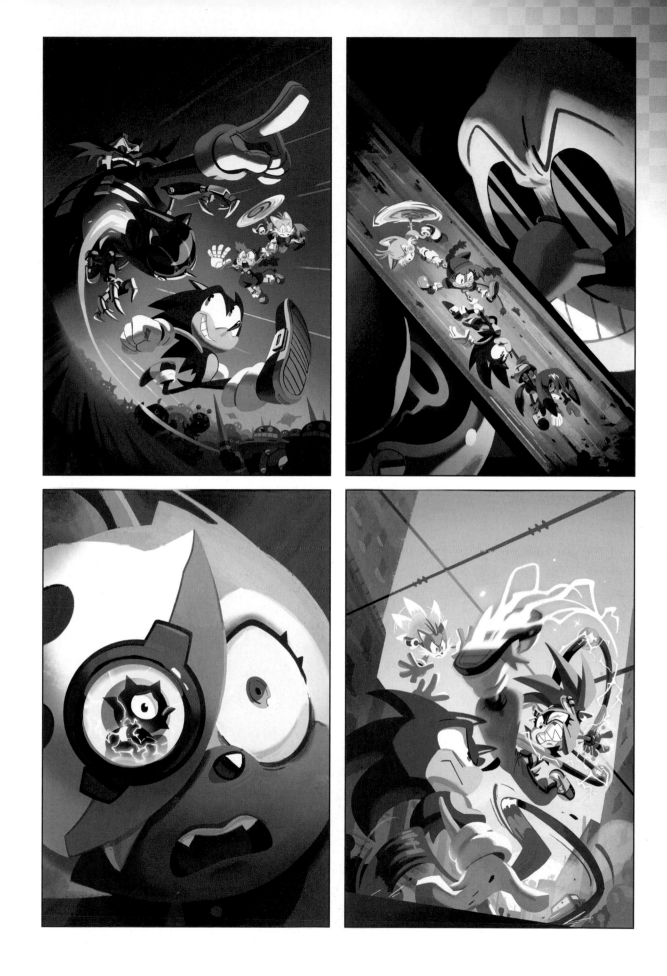

TOP LEFT
SONIC THE HEDGEHOG #51
INCENTIVE COVER
ART BY **NATHALIE FOURDRAINE**

TOP RIGHT
SONIC THE HEDGEHOG #52
INCENTIVE COVER
ART BY **NATHALIE FOURDRAINE**

BOTTOM LEFT
SONIC THE HEDGEHOG #53
INCENTIVE COVER
ART BY **NATHALIE FOURDRAINE**

BOTTOM RIGHT
SONIC THE HEDGEHOG #54
INCENTIVE COVER
ART BY **NATHALIE FOURDRAINE**

TOP LEFT
SONIC THE HEDGEHOG #55
INCENTIVE COVER
ART BY **NATHALIE FOURDRAINE**

TOP RIGHT
SONIC THE HEDGEHOG #56
INCENTIVE COVER
ART BY **NATHALIE FOURDRAINE**

BOTTOM LEFT
SONIC THE HEDGEHOG #57
INCENTIVE COVER
ART BY **NATHALIE FOURDRAINE**

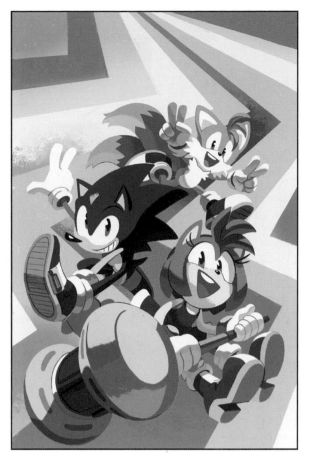

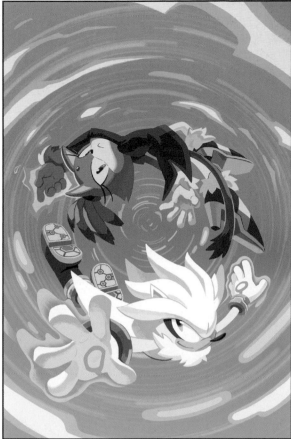

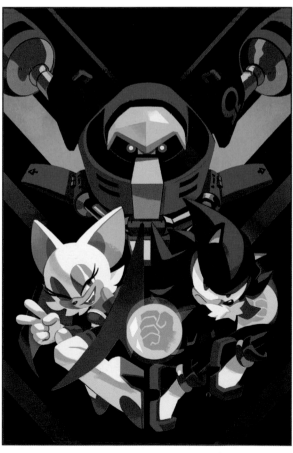

TOP LEFT
SONIC THE HEDGEHOG #58
INCENTIVE COVER
ART BY **NATHALIE FOURDRAINE**

TOP RIGHT
SONIC THE HEDGEHOG #59
INCENTIVE COVER
ART BY **NATHALIE FOURDRAINE**

BOTTOM RIGHT
SONIC THE HEDGEHOG #60
INCENTIVE COVER
ART BY **NATHALIE FOURDRAINE**

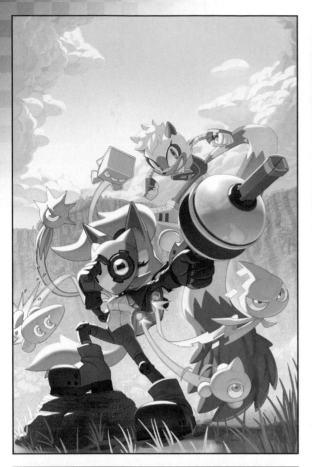

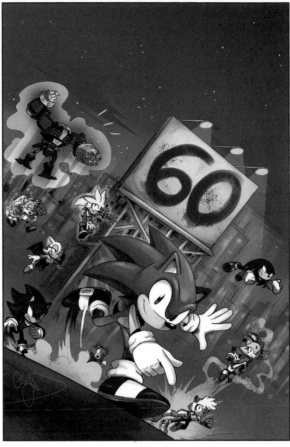

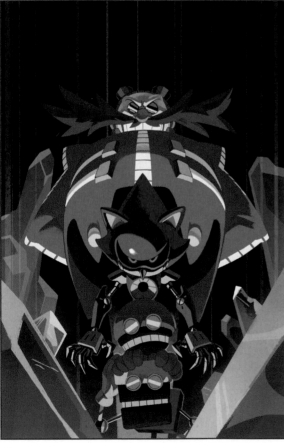

TOP LEFT
SONIC THE HEDGEHOG #57
COVER A
ART BY **MIN HO KIM**

TOP RIGHT
SONIC THE HEDGEHOG #60
EXCLUSIVE COVER
ART BY **GIGI DUTREIX**

BOTTOM LEFT
SONIC THE HEDGEHOG #61
INCENTIVE COVER
ART BY **NATHALIE FOURDRAINE**

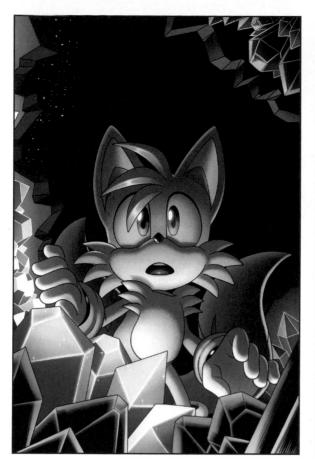

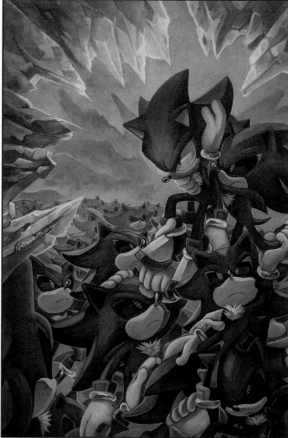

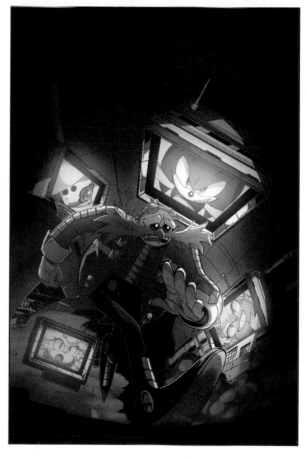

TOP LEFT
SONIC THE HEDGEHOG #58
COVER B
ART BY **ABIGAIL OZ**

TOP RIGHT
SONIC THE HEDGEHOG #59
COVER B
ART BY **NATALIE HAINES**

BOTTOM RIGHT
SONIC THE HEDGEHOG #61
COVER B
ART BY **MILES ARQ**

109

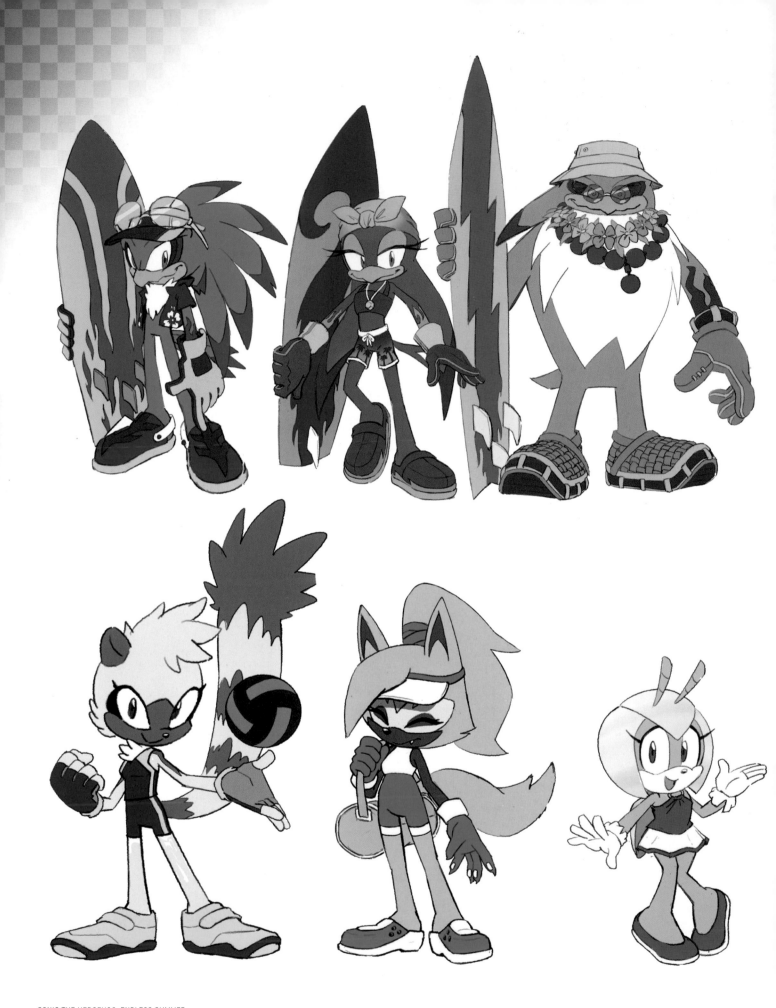

SONIC THE HEDGEHOG: ENDLESS SUMMER
BEACH OUTFIT DESIGNS AND CONCEPTS BY **TRACY YARDLEY**

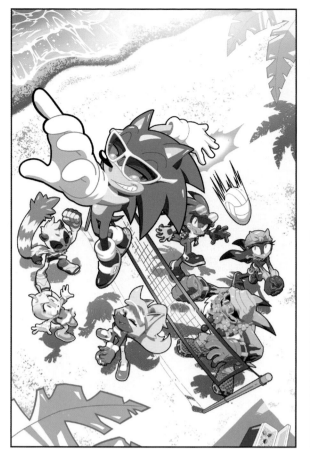

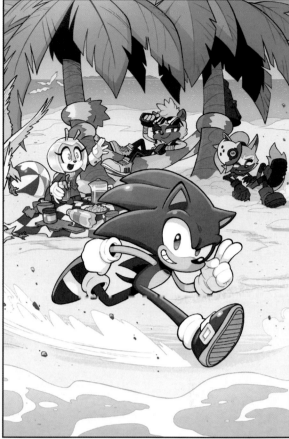

TOP LEFT
**SONIC THE HEDGEHOG:
ENDLESS SUMMER**
COVER A
ART BY **TRACY YARDLEY**

TOP RIGHT
**SONIC THE HEDGEHOG:
ENDLESS SUMMER**
COVER B
ART BY **JACK LAWRENCE**

BOTTOM RIGHT
**SONIC THE HEDGEHOG:
ENDLESS SUMMER**
INCENTIVE COVER
ART BY **NATALIE HAINES**

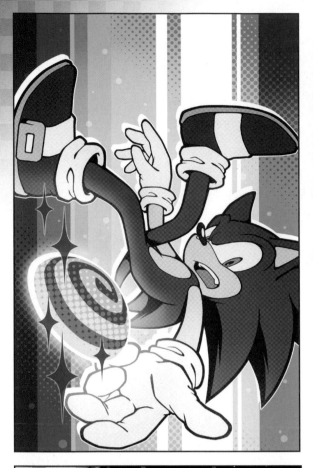

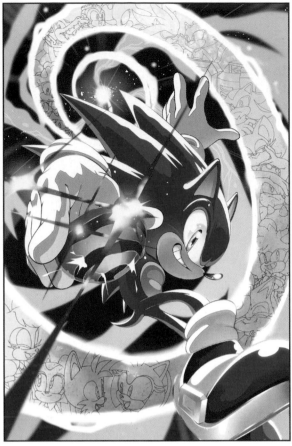

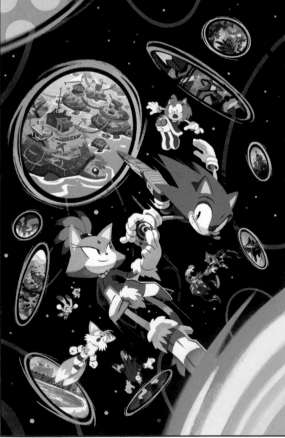

TOP LEFT
**SONIC THE HEDGEHOG'S
900TH ADVENTURE**
COVER A
ART BY **TRACY YARDLEY**

TOP RIGHT
**SONIC THE HEDGEHOG'S
900TH ADVENTURE**
COVER B
ART BY **YUJI UEKAWA** OF SONIC TEAM

BOTTOM LEFT
**SONIC THE HEDGEHOG'S
900TH ADVENTURE**
INCENTIVE COVER
ART BY **NATHALIE FOURDRAINE**

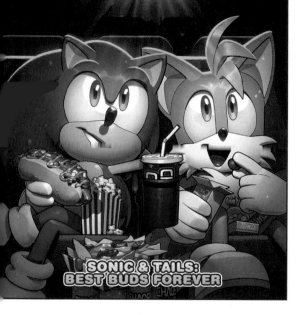

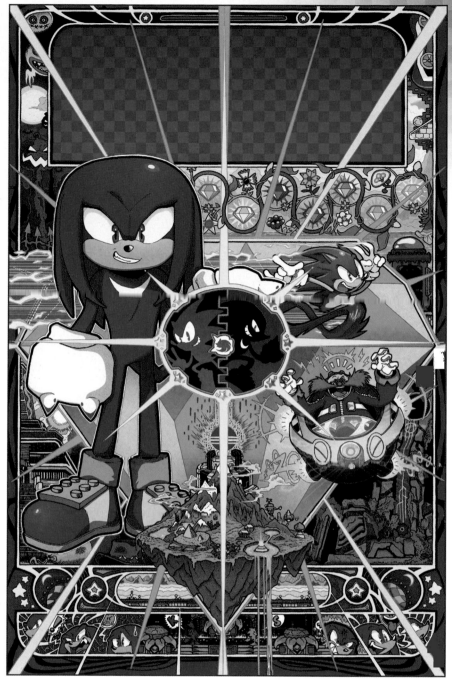

TOP LEFT

**SONIC THE HEDGEHOG:
SONIC & TAILS—
BEST BUDS FOREVER**
COVER
ART BY **EVAN STANLEY**

TOP RIGHT

**SONIC THE HEDGEHOG:
KNUCKLES' GREATEST HITS**
COVER
ART BY **JONATHAN GRAY**
COLORS BY **REGGIE GRAHAM**

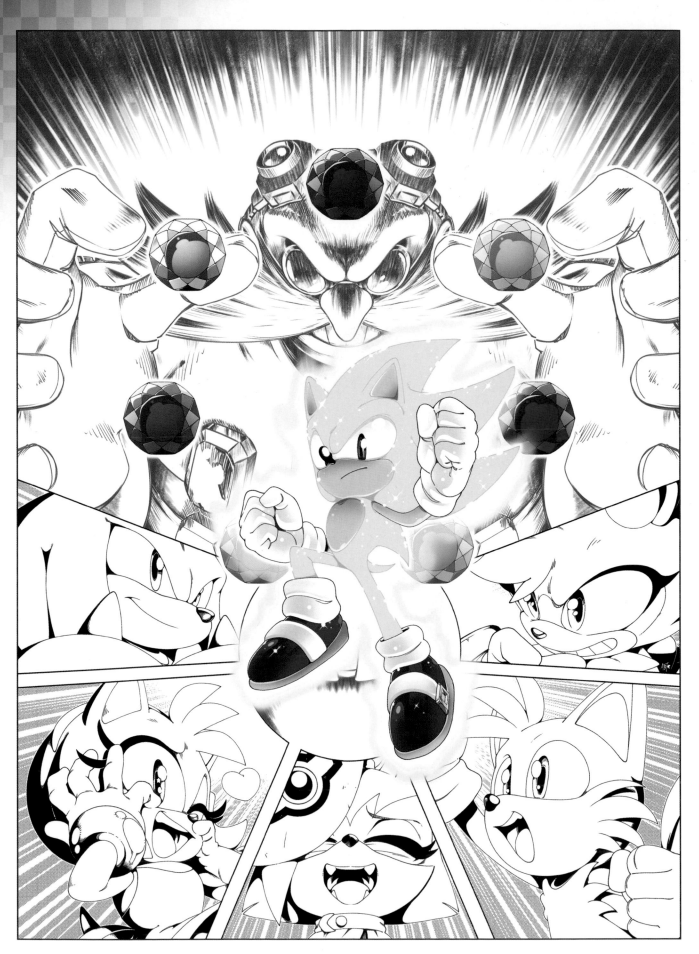

**SONIC THE HEDGEHOG:
THE IDW COMIC ART
COLLECTION**
EXCLUSIVE COVER
ART BY **ADAM BRYCE THOMAS**

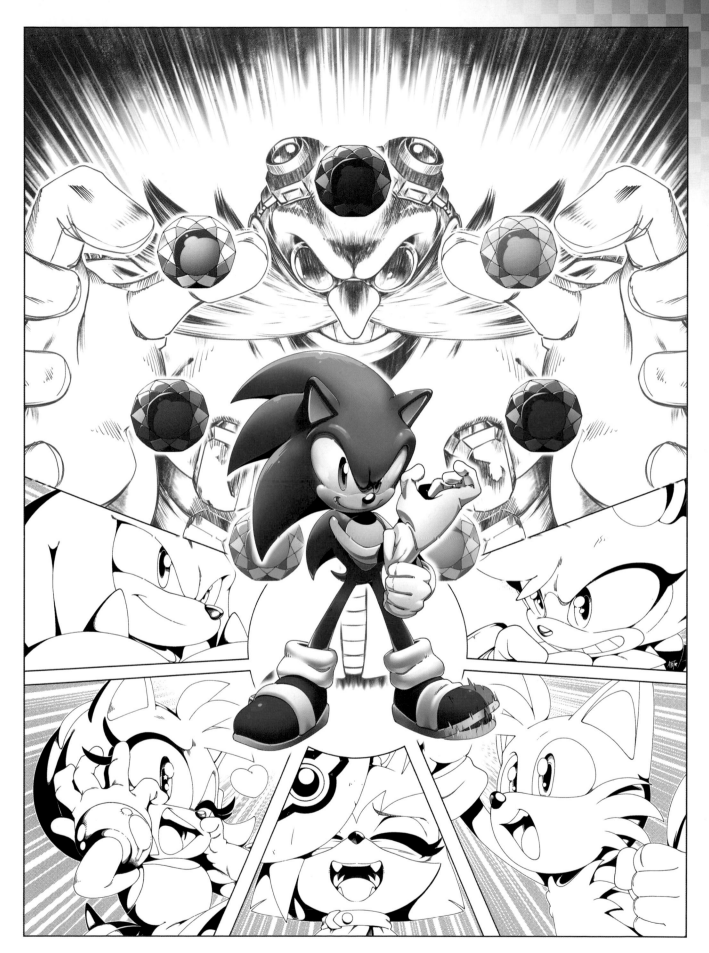

SONIC THE HEDGEHOG:
THE IDW COMIC ART
COLLECTION
COVER
ART BY **ADAM BRYCE THOMAS**

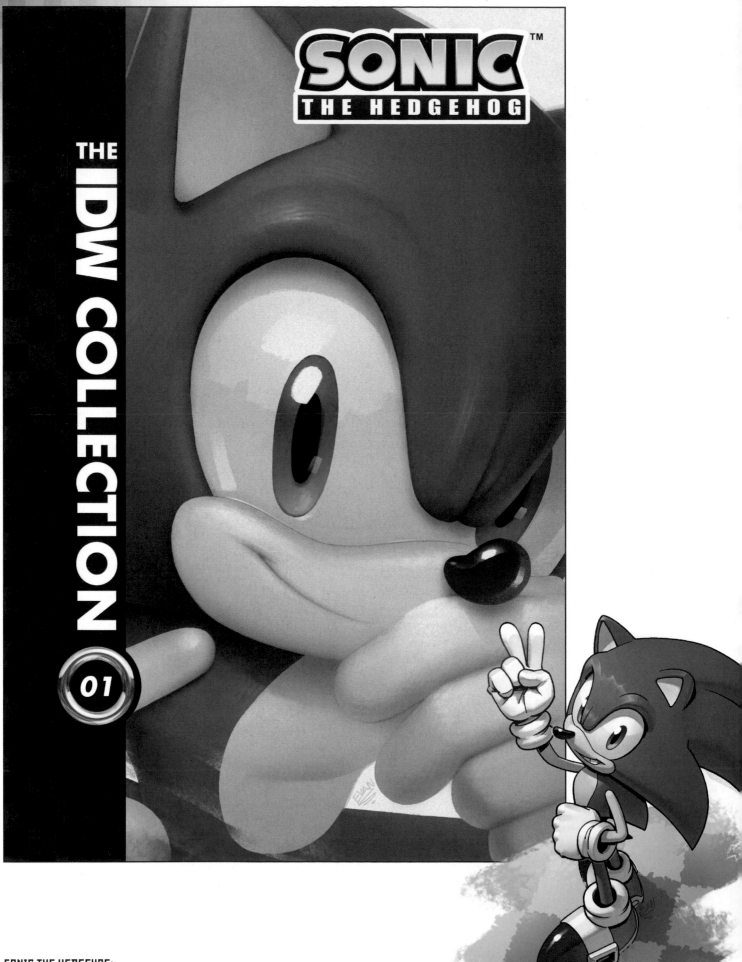

™

SONIC
THE HEDGEHOG

THE
IDW COLLECTION

01

SONIC THE HEDGEHOG:
THE IDW COLLECTION, VOL. 1
FRONT AND BACK COVER ART BY **EVAN STANLEY**

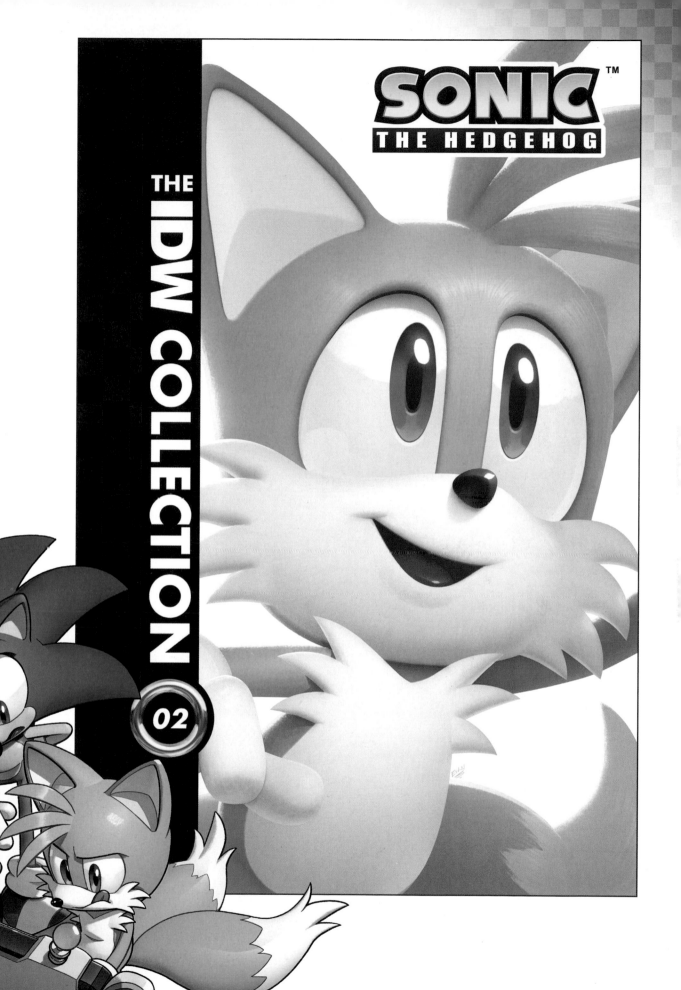

SONIC THE HEDGEHOG:
THE IDW COLLECTION, VOL. 2
FRONT AND BACK COVER ART BY EVAN STANLEY

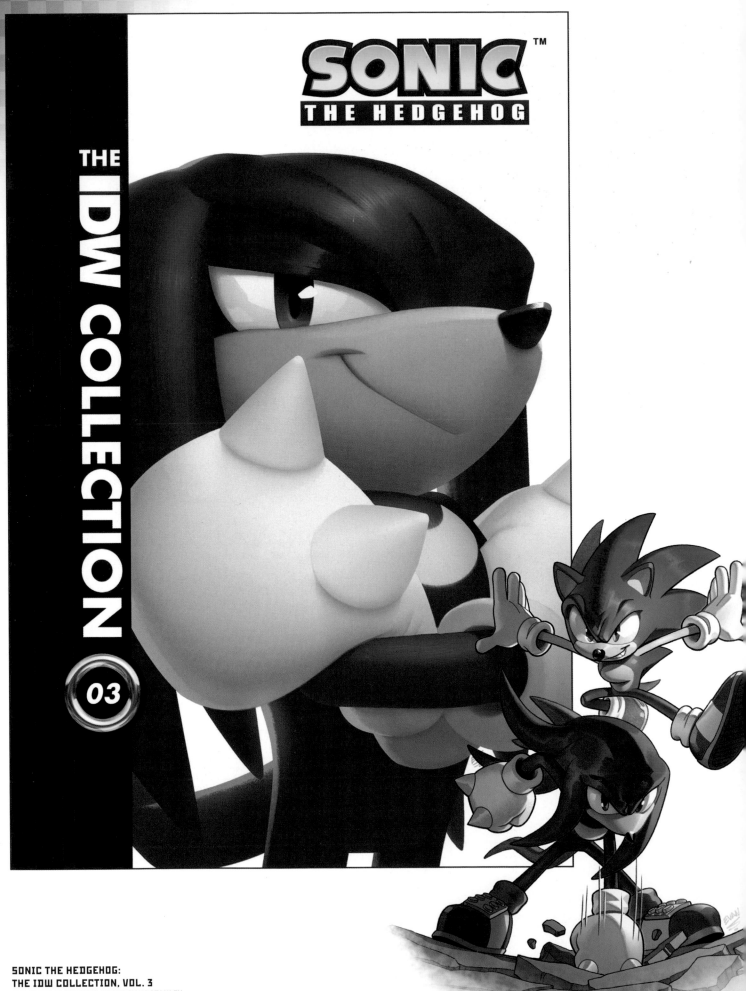

SONIC THE HEDGEHOG:
THE IDW COLLECTION, VOL. 3
FRONT AND BACK COVER ART BY EVAN STANLEY

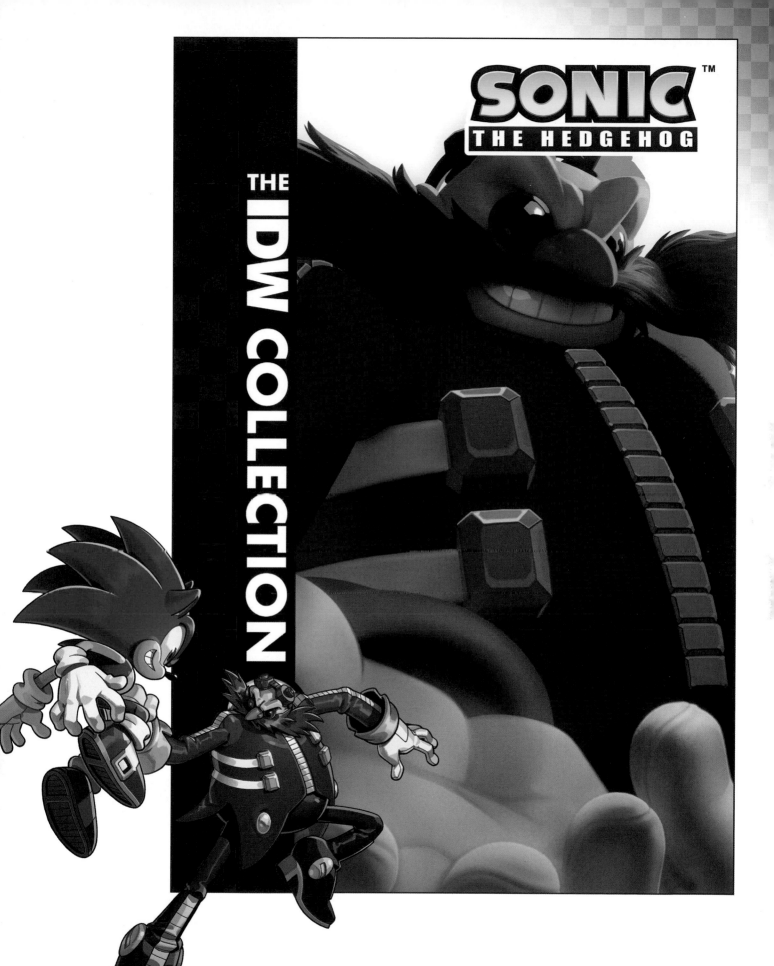

SONIC THE HEDGEHOG

THE IDW COLLECTION

SONIC THE HEDGEHOG:
THE IDW COLLECTION, VOL. 4
FRONT AND BACK COVER ART BY **EVAN STANLEY**

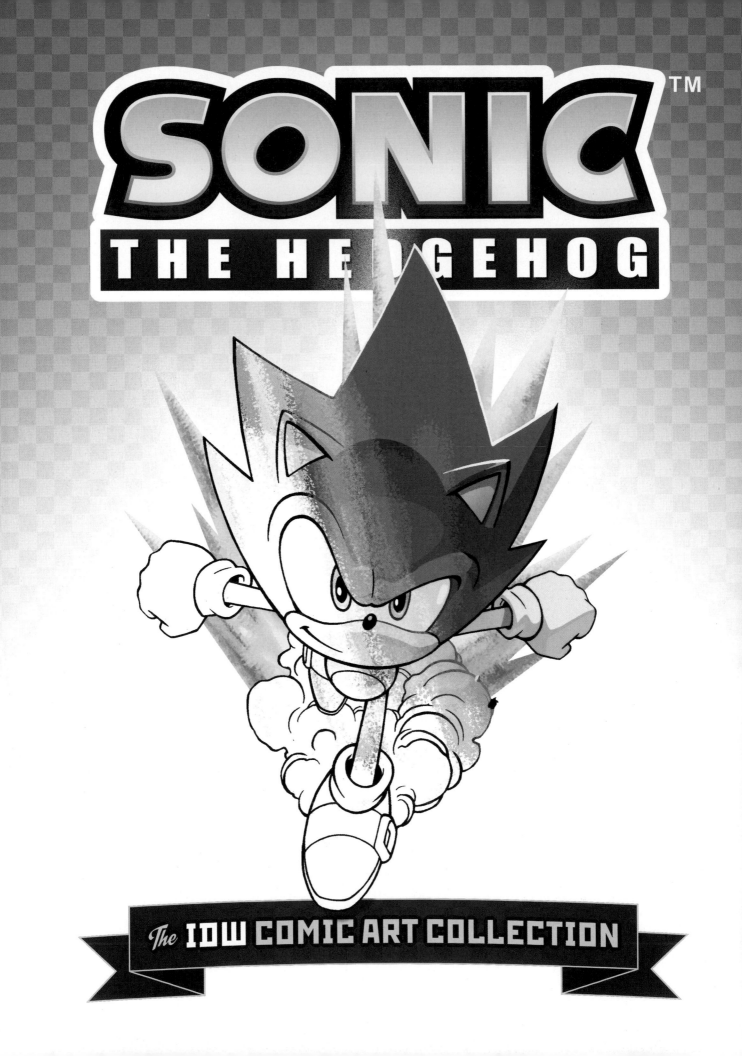